THEN & NOW

UTICA

Opposite: This photograph captures downtown Utica at its apex—Utica's many churches, celebrated architecture, and condensed street traffic are all in evidence. Looking south on Genesee Street, one notices that the "Busy Corner" of Genesee, Lafayette, and Bleecker Streets needed to accommodate trolley, foot, and automobile traffic, as it essentially served as a pivot point for travelers on their way to government buildings as well as the popular theater and shopping districts.

UTICA

Joseph P. Bottini and James L. Davis

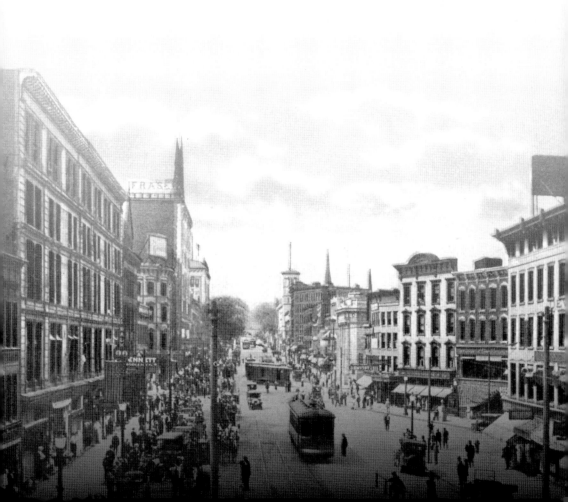

Glory to God in Christ Jesus. For my family, Mary, Maria, Rich, Michelle, Tom, Mia, Thomas, and Danielle; parents Joseph and Rosaria; Ron Campion; Paul Pomilio; and those maintaining our liberty.
—*Joseph P. Bottini*

I wish to thank all those who have both supported this book and been a source of optimism for the Mohawk Valley.
—*James L. Davis*

Copyright © 2007 by Joseph P. Bottini and James L. Davis
ISBN 978-0-7385-5496-9

Library of Congress control number: 2007927920

Published by Arcadia Publishing
Charleston SC, Chicago IL, Portsmouth NH, San Francisco CA

Printed in the United States of America

For all general information contact Arcadia Publishing at:
Telephone 843-853-2070
Fax 843-853-0044
E-mail sales@arcadiapublishing.com
For customer service and orders:
Toll-Free 1-888-313-2665

Visit us on the Internet at www.arcadiapublishing.com

On the front cover: A view of the M and T Bank corporate headquarters on Genesee Street, as captured by photographer Ryan Orilio in April 2007, compares to the original Savings Bank of Utica captured in an antique postcard. The "Gold Dome Bank," capped with a veneer of actual gold, opened for business at the beginning of the 20th century and has been a dominant part of Utica's subtle skyline for generations. The vintage photograph was produced by Raphael Tuck and Sons, "art publishers to their majesties the King and Queen." (Contemporary photograph, courtesy Ryan Orilio Photography; historic photograph, courtesy Joseph P. Bottini.)

On the back cover: Please see page 95. (Courtesy Joseph P. Bottini.)

CONTENTS

ACKNOWLEDGMENTS

All modern images, specially provided for this book, are the work of Ryan Orilio Photography. All graphic restoration and art direction was provided by graphic artist Mark D. Chetnik. A special thanks to Frank Tomaino, foremost local historian and writer of "This Week in History" for the *Utica Observer-Dispatch*. A majority of the vintage images are from Joseph P. Bottini's personal antique postcard collection.

Permission has been given to the authors to reproduce several historic pictures provided by the Oneida County Historical Society (OCHS), with technical assistance by Carl Saparito and encouragement from OCHS director Rick Allen. In addition, several vintage pictures are reproduced courtesy of Partners Trust Bank.

We are also indebted to the support, advice, and dedication of the following individuals: Phil Arcuri, Carmela M. Brown, Joseph Carucci, Clinton Senior High School Media Center, Diana Cullen, Amy Dickenson, Matthew Dolansky, H. Paul Draheim, Dave Dudajek, Ray Durso, William (Jim) Griffin, Mayor Timothy J. Julian, Audrey Lewis, Jim Meehan, Pam O'Neil, Louis Perrota, Betty M. Servatius, the staffs at HSBC and Partners Trust Bank, Allen Paul Stalker, Gary Wereszynski, Tammy Wheeler, Larry Whitney, and most notably our wives, Mary (Nelson) Bottini and Karen (Schneible) Davis.

Other sources used to create this work include the following: "Historic Homes of Noted Uticans" by William W. Ames, included in *The Way To Wealth*; "Refugees Revitalizing Utica" from the *Buffalo News*; *Utica: For a Century and a Half* by Dr. T. Wood Clarke; *The Grammar of Architecture*, Emily Cole, general editor; *A History of New York State* by David M. Ellis, et al.; *His Excellency, George Washington* by Joseph J. Ellis; *Sesquicentennial Scrapbook* by Joe Kelly; *A Sketch of Old Utica* by Blandina Dudley Miller; *Utica: A City Worth Saving* by Frank E. Przbycien; *Outline History of Utica and Vicinity* by the New Century Club Committee; *The History of Oneida County*; "This Week in History" by Frank Tomaino of the *Utica Observer-Dispatch*; *Vignettes of Old Utica* by John J. Walsh; *Exploring 200 years of Oneida County History*, edited by Donald F. White; *The American Revolution* by Gordon S. Wood; www.rootsbweb.com for information on the Utica State Hospital; and "A City in Decline Fighting to Preserve Its 1800's Heritage" by Michelle York, published in the *New York Times*.

INTRODUCTION

The city of Utica offers a concentrated urban experience that grants easy access to all the opportunities it has to offer. As locals still like to say, "Everything in Utica is five minutes away." Utica's 16 square miles have made navigating the city easy for commuters, both past and present. It also offers a convenient context for intellectual reflection on city life. Utica is a relatively small city in comparison to Syracuse, Rochester, or Buffalo, yet it possesses many of the same attributes as these larger urban centers, without the confusing, often disillusioning, effect that big-city life can have on inhabitants, tourists, or students of urban history.

The story of the city of Utica, past and present, is as inspiring as it is cautionary. Like many other northeastern cities in the United States today, it boasts of a history vibrant in urban achievement while it struggles to redefine itself in the face of suburbanization and postindustrialization. The evolution of Utica's cityscape reflects the ambitions of an earlier era alongside the practical realities of contemporary city life. While the values and dreams of previous generations are obvious in the city's existing architecture, what is also present is that which is absent—architectural gems removed long ago that leave no trace of their original grandeur. Utica, at one point in the history of this country, was certainly "someplace." Its experience in the last couple of decades provides American society with a provocative lesson in how we treat the urban centers that we build, or, just as importantly, how a city may survive the ups and downs of an increasingly global economy.

In years past, Utica, the seat of Oneida County government, was the cultural nexus of central New York. Despite years of population loss and urban decay, it still is. This suggests something important about how people in the Mohawk Valley, or perhaps Americans in general, regard urban areas. It has been said that American society exists in a constant tension between city living and the need for open spaces. While people may yearn for life in the suburbs, they certainly do not want to see a city like Utica entirely disappear. As our living trends evolve, folks still look for a civic and cultural center, and for people of the Mohawk Valley, Utica continues to fill that role. Then & Now: *Utica* shows the many offerings that Utica has provided for people in this region since the 18th century and points to the potential that the city has for the Mohawk Valley in the 21st century.

Utica benefited from being centrally located relative to the major metropolitan areas of the Northeast, thus experiencing significant economic and political accomplishments in its first century and a half. It was the home of the world's largest textile industry, the home of major leaders in the national Republican and Democratic Parties (and therefore the site of major political party conventions), and an early American urban crossroads for our most celebrated leaders, thinkers, inventors, and entertainers. As a halfway point for travelers on the Erie Canal, the city was a source of much-needed rest and relaxation for

the weary traveler. In time, Utica developed the reputation as an entertainment mecca for its expansive theater district and off-Broadway shows.

In the last 50 years, however, Utica has had a difficult time maintaining a vibrant image. The city has lost nearly half its population (at its peak approximately 110,000) to suburbanization and postindustrialization, losing nearly half its downtown architectural presence in the process. As employers such as Chicago Pneumatic Tool Company and General Electric closed their doors, Utica faced a financial crisis that created negative public and private attitudes that questioned the city's ability to stay relevant to changing times.

The closing of the nearby Griffiss Air Force Base in Rome (often called Utica's "twin city") in the mid-1990s symbolized both a considerable blow to the regional economy and a proverbial last straw for politicians and business leaders. The Mohawk Valley seemed to suffer a knockout punch economically yet also experienced a call to arms to essentially preserve a once proud region.

The city of Utica has been a center of these efforts for the past 10 years, albeit at a slower pace than elsewhere in the region. The former U.S. Air Force base in Rome has redefined itself as a technology center and is once again a major regional employer. The Turning Stone Casino and Resort, located on the traditional lands of the Oneida Indian Nation (a 20-minute drive from the city) has also become a major regional employer and a popular tourist destination. As areas around the city thrive, the emphasis of growth in the city has been on small industry, medical technology, public service companies, cultural attractions, and education. Once abandoned buildings are being filled with new tenants, colleges are expanding, and small businesses are growing. Population losses have lessened in intensity, helped by the influx of immigrants and political refugees. In the process, neighborhoods have been transformed in a very noticeable way compared to 10 or even 5 years ago.

In the mid-1990s, a book such as this may have seemed a nostalgic pictorial history of a city, a shadow of its former self. Today Utica is a source of optimism and new opportunity. This book hopes to instigate interest in this city.

Our visit to a local bookstore inspired this book. Seeing so many recent publications focused on many local history topics, we could not understand why authors had not decided to tackle a book about Utica that could reach a national audience. One of us had wanted to write a book about Utica for 30 years, the other for the past 3. Both of us have enjoyed the rare opportunity to renew a scholarly relationship that began as a classroom dynamic between a teacher (Joseph P. Bottini) and student (James L. Davis) and grew from a mutual passion for history and for our region.

CHAPTER 1

PRESERVED TREASURES AT "NEW YORK'S CROSSROADS"

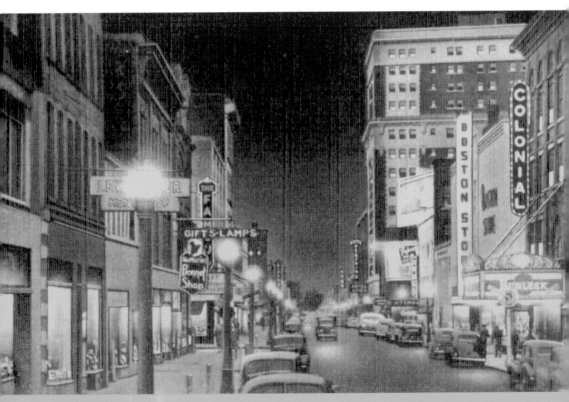

According to Hon. Timothy J. Julian, mayor of the city of Utica, "The city of Utica is doing everything it can to preserve its rich architectural heritage. The architecture in this city is second to none, and it is an embodiment of the keen eye our forefathers had when they erected some of the most glorious and prestigious buildings not only in our city but the entire country. We are saving these links to our past one brick at a time."

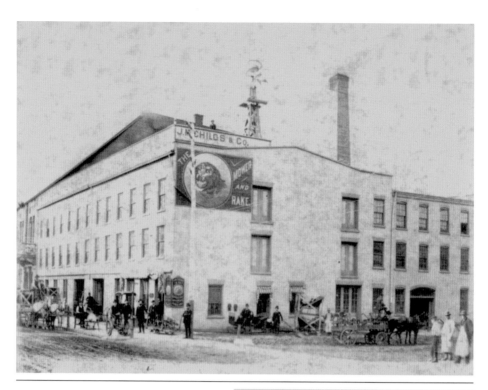

Hotel Utica began earning its reputation for luxurious confines, gourmet dining, and a celebrity guest list in 1912—with some interruptions along the way. This northwest corner of Lafayette and Seneca Streets was originally the home of the Charles H. Childs Company, a carriage, agricultural equipment, and later automobile distributor. Hotel Utica has experienced several significant transformations since its inauguration, such as adding four stories in 1926. (Historic photograph courtesy OCHS.)

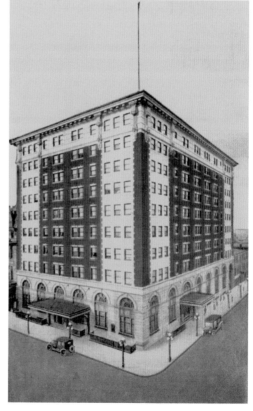

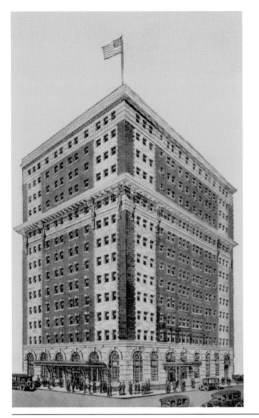

The hotel served as a residential care community and nursing facility into the mid-1970s when it was soon after vacated and left to deteriorate. Local real estate developers Joseph R. Carucci and Charles Gaetano Jr. came to the hotel's rescue in the late 1990s, initiating a major restoration and then reopening the hotel in 2001. Historic Hotel Utica offers conference space and 300 guest rooms and is a member of both the Clarion Collection of hotels and the Historic Hotels of America National Trust.

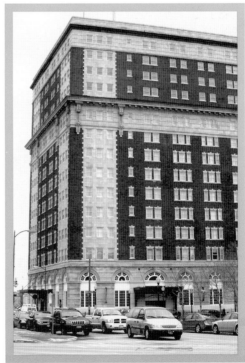

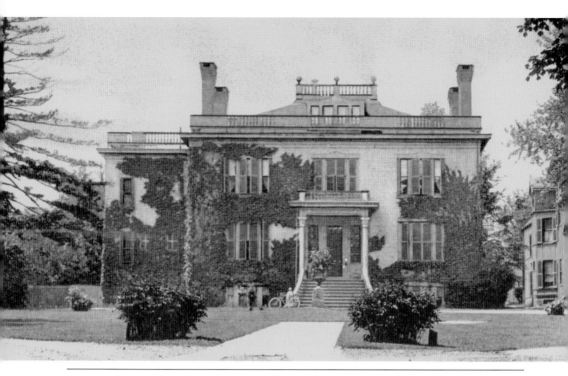

This house at 3 Rutger Street was known as "Miller's Folly" in the 1830s because it was built for its original resident a considerable distance from downtown. It was the home to several Utica luminaries, including Roscoe Conkling, who distinguished himself as a Utica mayor, U.S. congressional leader, and Republican Party stalwart. Conkling hosted many dignified events here, including the 1875 reunion of the Army of the Cumberland, with generals Ulysses S. Grant, William T. Sherman, and Joseph Hooker in attendance. The site is currently on the list of national historic landmarks and at the time of this printing the property has gained local and national attention from real estate investors.

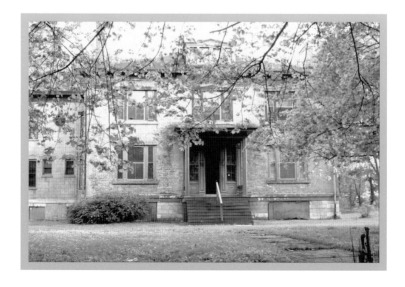

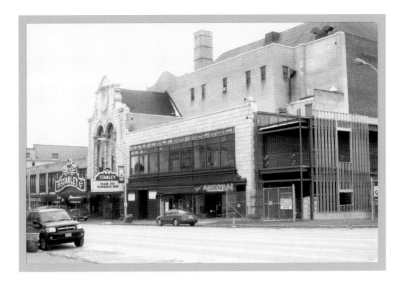

This cultural treasure on 259-261 Genesee Street was erected by the Stanley Mark-Strand Corporation in 1928 at a cost of $1.5 million. Thomas W. Lamb, New York City architect of Madison Square Garden and the Strand Theatre, drew its initial designs on his interpretation of the Mexican baroque style. The theater maintained its elegant atmosphere through major renovations over the years, serving as a concert hall, movie theater, and Broadway Theatre League showcase. With regional support, the Stanley initiated a multimillion-dollar Stanley World Stage renovation project starting in March 2007, with a final show by jazz legend Wynton Marsalis. (Historic photograph courtesy OCHS.)

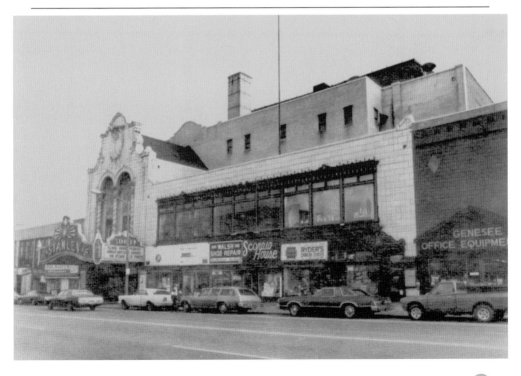

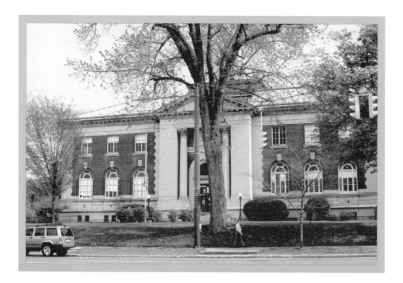

Several Utica business legends—Theodore Faxton, Thomas R. Proctor, and Frederick T. Proctor—were instrumental in establishing a permanent home for the Utica Public Library as it now stands at 303 Genesee Street. With money donated for books from Faxton and land donated by the Proctors, the cornerstone for the library was laid in 1903, and the library opened to the public in 1904. A seven-foot-tall statue of Gen. George Washington sculpted by Benjamin Thorne Gilbert has stood guard on the library's front lawn since 1959. Gilbert titled his work *The Vision* in honor of Washington's perseverance at Valley Forge.

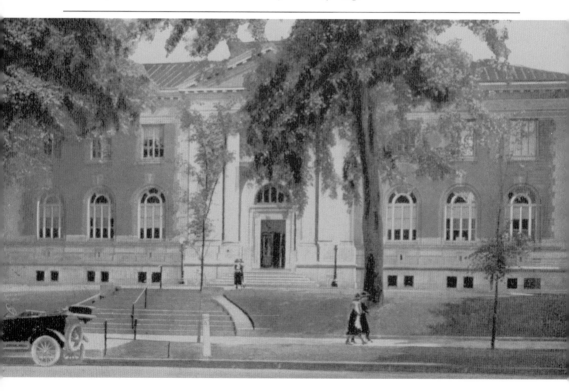

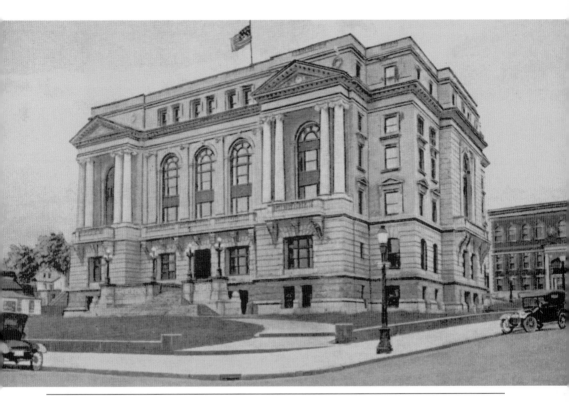

This Palladian-style courthouse was first opened in 1909 on the southeast corner of Elizabeth and Charlotte Streets. This building replaced the John Street Courthouse of 1800s renown, where many famous jurists, including U.S. vice president (and, more notably, Alexander Hamilton's assassin) Aaron Burr, argued cases. The Corinthian columns were removed, and additions were made to serve its several courtrooms. Today the courthouse serves New York State's Fifth Judicial District with newly restored second and third floors with larger jury rooms and state-of-the-art courtroom technology.

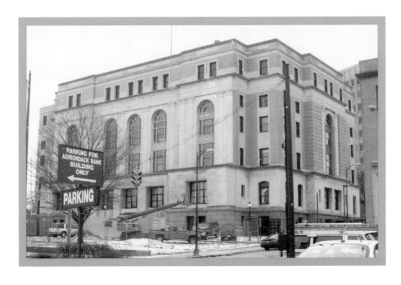

This twin-steeple church on the southwest corner of Bleecker and John Streets is the home of the oldest parish in the Syracuse Catholic diocese. The current structure dates back to the years immediately following the American Civil War, with its distinctive steeples affixed during the late 1890s. The first church, a wooden structure, was built on this site in 1821 from land donated by a Protestant, Judge Morris Miller. It is now known as "Historic St. John's Church," and the parish remains active after more than 185 years.

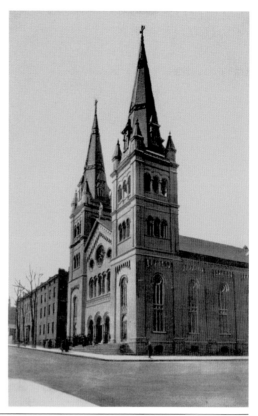

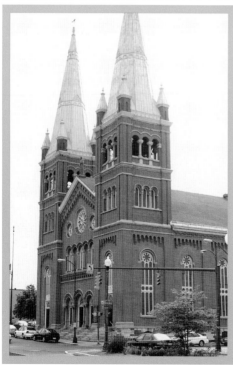

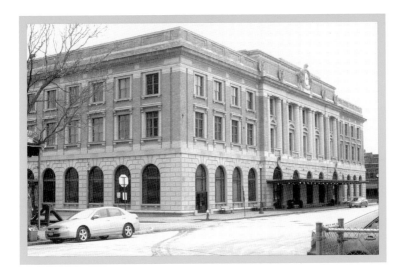

Train stations have been located at this location, Main Street east of Bagg's Square, since the Schnectady Railroad established its business there in 1836. The Utica Union Station, designed by New York City architects Allen H. Stern and Alfred Fellheimer, began operation in 1914 under the New York Central Railroad. With ownership recently being transferred to Oneida County, the site not only serves Amtrak and the Adirondack Scenic Railway but also provides the county and Department of Motor Vehicles with renovated office space. It is now named Boehlert Center at Union Station in honor of U.S. congressman Sherwood Boehlert, a Republican in New York's 24th Congressional District, who advocated for the region's transportation needs in his more than 20-year tenure in the House of Representatives.

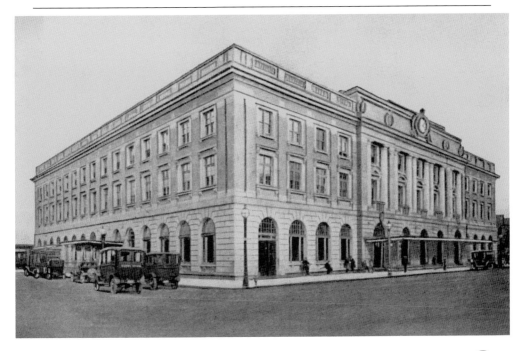

One of Utica's most prominent landmarks is the golden domed M and T Bank at 233 Genesee Street. The address was originally the Greek Revival–style home (right) of Utica lawyer John H. Lothrop and later Abigail Johnson (granddaughter of founding father John Adams). The removal of this house made room for the Savings Bank of Utica (below) in 1900, although the new building preserved the site's architectural heritage by including prominent Corinthian columns. (Right photograph courtesy Partners Trust Bank.)

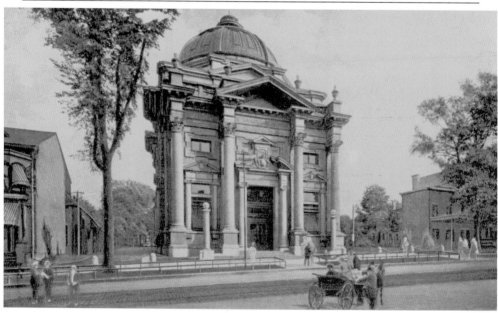

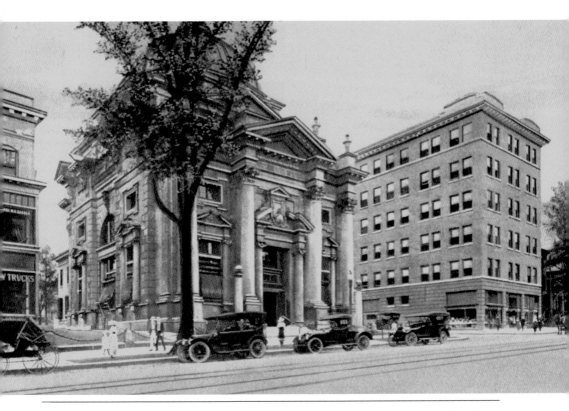

The gold-leafed exterior dome protects a series of oil-based murals on the indoor ceiling by painter Frederick Augustus Marshall. Since opening, the building has experienced the addition of Bank Place, its neighbor the Mayro Building (southeast corner of Genesee Street and Bank Place), and its own international-style office addition on its north side.

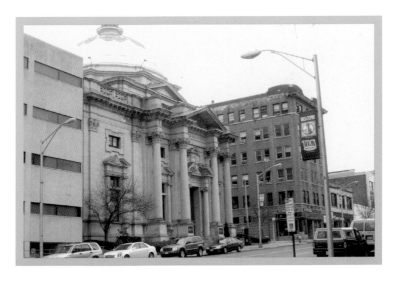

American architectural expert Prof. Henry-Russell Hitchcock noted that "no European public edifice has a grander Greek Doric portico than that which dominates the tremendous four story front block" of what many locals still refer to as "Old Main," the main building of the Utica Psychiatric Center at 1213 Court Street. Listed on the National Register of Historic Places, it was the first hospital to serve patients with mental illness under the auspices of New York State, opening its doors in 1843. The campus looks to expand its role beyond its current use as a state records center.

PRESERVED TREASURES AT "NEW YORK'S CROSSROADS"

PUBLIC SANCTUARIES IN "SINCERITY CITY"

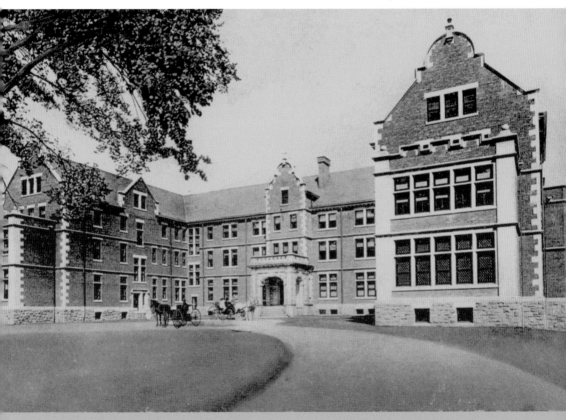

Kate and Don Robertson, Utica-area health care professionals, note that "the character of a community is measured by the way it responds to its responsibilities for the sick, poor and elderly . . . the Mohawk Valley Heart Institute is just one recent example of Utica's continuing progress in health care." This tradition of caring began in places like the old St. Luke's Hospital pictured here, which opened in 1905. Set apart by its Jacobean-style rounded gables, it was financed by another institution with a tradition of service to Utica—the Frederick T. Proctor family.

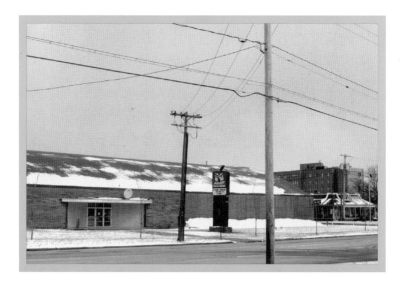

This facility, located at 1700 Genesee Street, opened its doors in 1904 with funds donated by Thomas Proctor in order to expand the House of Good Shepherd's original intent beginning in 1872: to help children at risk due to family hardship. The building, made distinctive by its rounded gables of the Jacobean style, was eventually replaced by bowling lanes (now operated by Pin-O-Rama), a Travelodge motel, and later a McDonald's restaurant. The House of Good Shepherd eventually moved to the suburb of New Hartford.

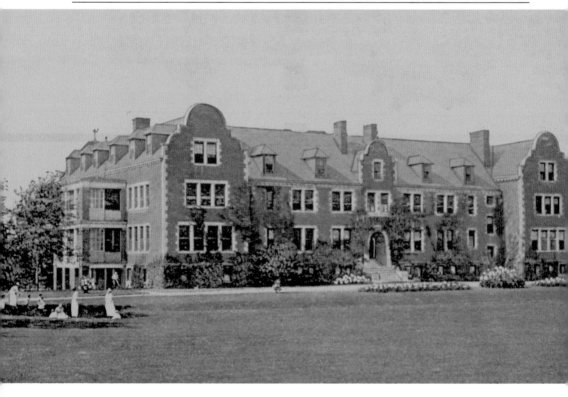

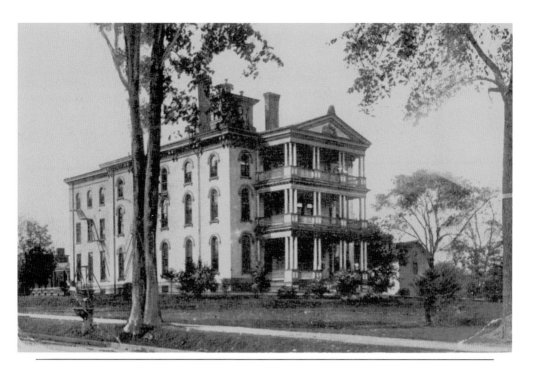

This imposing hospital building stood on the southwestern corner of Mohawk and South Streets for a little more than a century and began caring for patients in 1856. Once known as the City Hospital, established for the care of those with little means, it became known as General Hospital or "the General." This Greek Revival structure underwent both name changes and structural improvements until it was removed in 1959. The site was redeveloped by the Chicago Markets Realty Corporation, and for the past several decades, the former corner lot of the hospital has served as a shopping center for East Utica residents (below).

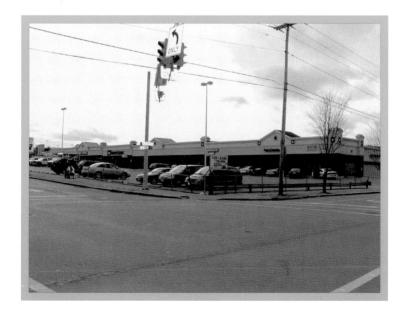

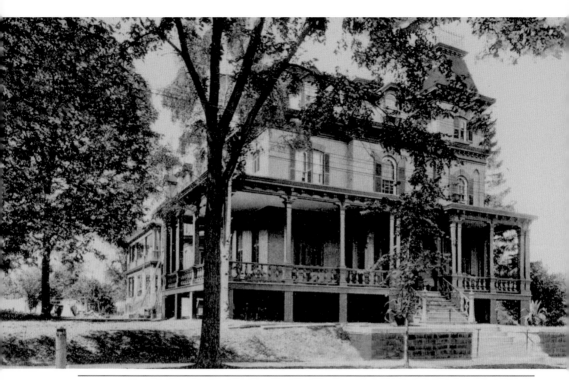

Theodore Faxton helped make funds possible for this facility at 32 Faxton Street. Known by several names over its century-plus service to the community—such as the Home for the Homeless and the Old Ladies Home—it finally settled on the Faxton Street Nursing Home into the late 1970s, when the structure was discarded for a new facility on Sunset Avenue (see page 33). In the early 1980s, local government officials planned to turn the Faxton Street home into apartments, only to see fire destroy the building. Still, the city stood by its original plans, and apartments fill the home's initial footprint, as seen below.

This site was purchased for the school upon the crowding of the rooms being used to house orphans at Assumption Academy on John Street. A 1925 fire ravaged the St. Vincent's Industrial School seen below, ruining an architectural pattern that mixed Gothic-themed windows with a variation of mansard-style roofs. Bordered by Rutger and Taylor Streets and Conkling Avenue, the facility provided both vocational training and sanctuary for young boys beginning in 1906. The Maronite Catholic Church, St. Louis Gonzaga, maintains its parish on this location today.

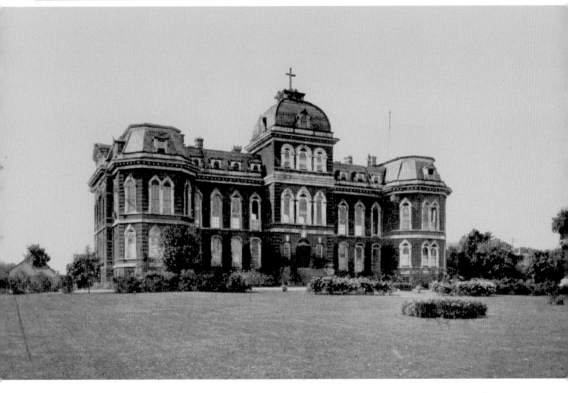

The Utica Homeopathic Hospital (below), first opened in the Butterfield residence on this site, served a brief tenure from 1895 to 1914. In 1899, it established a training school for nurses. This building was eventually replaced with a modernized facility that opened in 1916. In 1927, its name was changed to the Memorial Hospital, which ultimately incorporated with St. Luke's Hospital. Today the site is the home of the First Source Credit Union on 1634 Genesee Street north of the parkway.

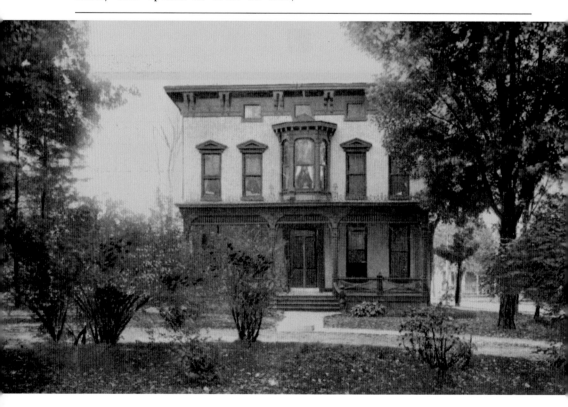

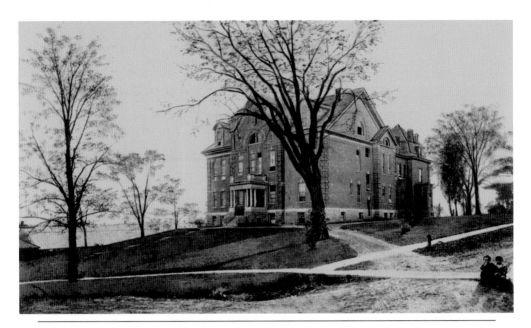

The building above once served as a private residence dating back to the 1830s but began serving orphaned children in 1894. Started in a home on Cottage Place, St. Joseph's moved to a larger home on Rutger Street in 1895 and purchased this home on Green Street in 1899. It was staffed by the Sisters of Charity, and the facility gained national renown for its progressive agenda. By the late 1940s, its occupants were transferred to the St. John's Orphan Home (Asylum) associated with historic St. John's Church. The Michael Walsh Apartment project now occupies this site, situated between Green and Gray Streets on Utica's west side.

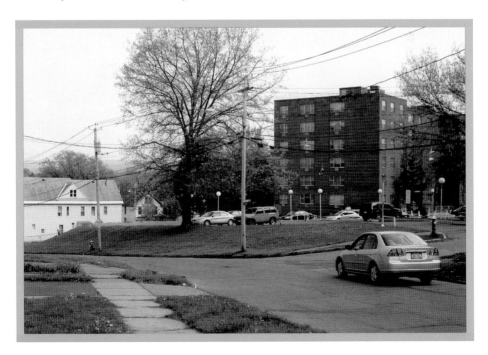

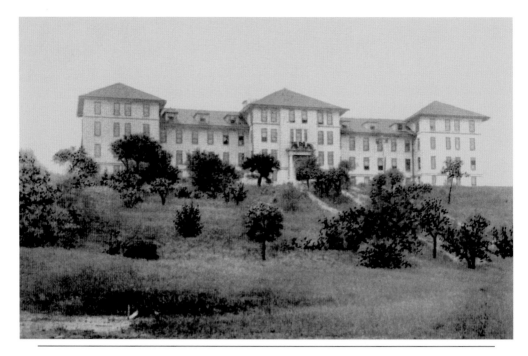

Opened in 1834, the funds for the St. John's Orphan Asylum were furnished by the first mayor of the city of Utica, John C. Devereux, proving that his works of charity were equal to his high reputation as "a very prince among his fellows." By 1853, five years after Devereux's death, the orphanage had "ballooned to a three story building of formidable dimensions" according to the *Utica Observer.* In 1901, the orphanage moved to upper Genesee Street, later serving as Utica Catholic Academy before becoming an apartment complex—the Academy at Southgate.

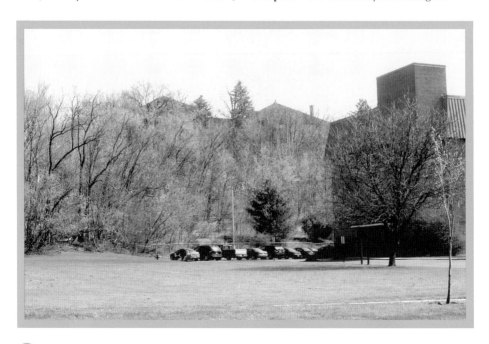

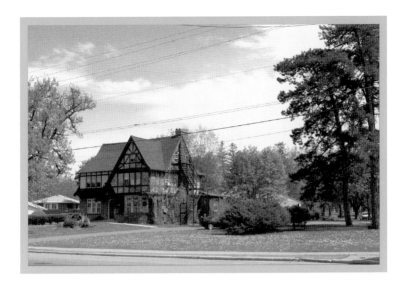

Motorists now pass the corner of Pleasant and Genesee Streets unaware that the Utica Orphan Asylum served the public from that address for nearly three generations. Founded by the Female Society of Industry, the orphanage began construction in 1860 and was open until 1924, when its residents were transferred to other facilities. The lot was redeveloped for residential space and made way for a new street, Derbyshire Place, named in memorial for a prominent member of the group that founded the asylum.

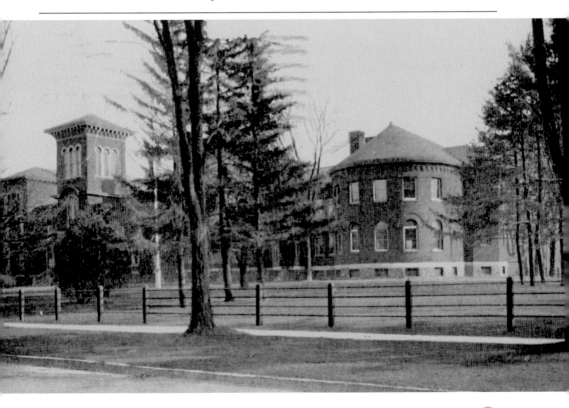

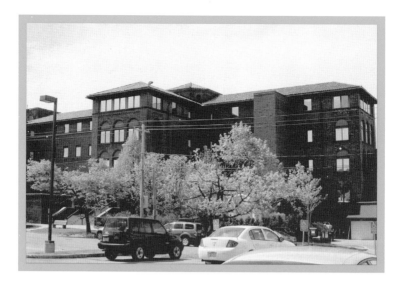

The original Faxton Hospital seen below, between Bennett, Hagar, and Newell Streets, was endowed with a total of $75,000 by prominent Utica businessman Theodore Faxton and was completed by 1875. With few patients in the beginning, the upper floors were a home for aged men, the predecessor of the Home for Aged Men and Couples (see opposite page). An addition was constructed in 1926, becoming the children's hospital home, and in 1931, the Utica Central School of Nursing began operating here as well. The facility pictured above served the city until 1941, and its present, more modern facility is now part of Faxton–St. Luke's Health Care System.

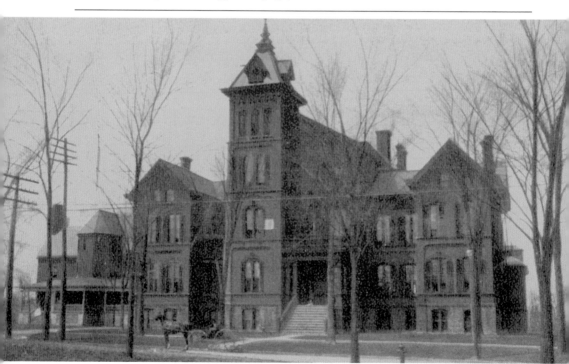

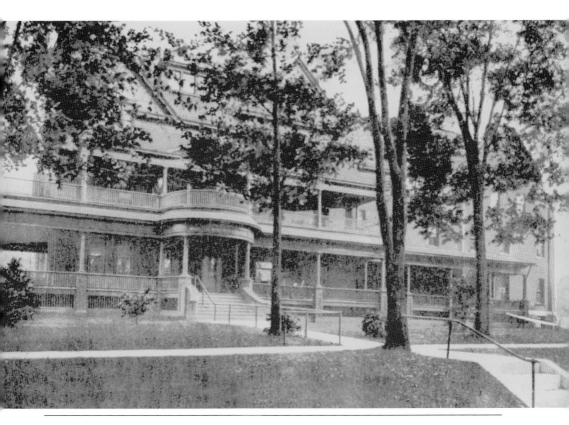

This beautiful home for adult men was located on the east side of Sunset Avenue, at the northeast corner of Burrstone Road. The land was purchased in 1889, the home opening in 1891. Its aim was to provide a home for the city's aged men, eventually changing its policies to accommodate elderly couples. It later became known as the Sunset Home. It was razed in the early 1970s and is now the site of the new Heritage Health Care Center.

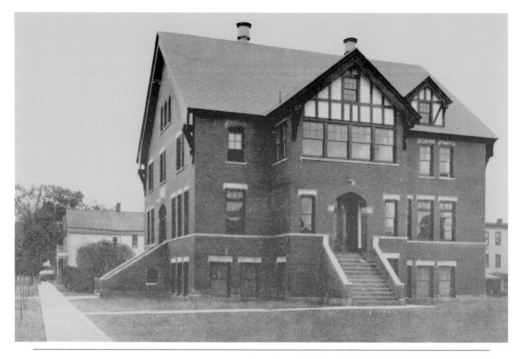

The Italian Settlement House opened its doors on Mary Street in 1910, specifically to assimilate Italian immigrants to American life. As East Utica welcomed a greater variety of immigrant groups to the neighborhood over the years, the neighborhood center was born and continued to thrive with community support. At this facility, Marie Russo, Utica's version of Chicago's Jane Addams (of Hull House fame), began using its programs as a child, later serving as a social worker at the facility and eventually becoming its executive director. The structure slightly blends a Tudor-style facade and is part of the neighborhood center complex on 628 Mary Street, which today provides educational and health care support to the immediate community.

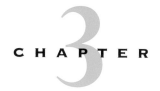

CHAPTER 3

PUBLIC BUILDINGS
IN THE
"HANDSHAKE CITY"

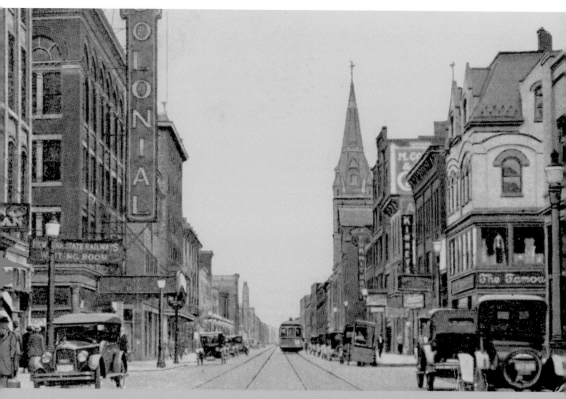

Raymond Durso, executive director of the Genesis Group (a regional civic action organization), knows that part of forging a future identity for cities such as Utica involves preserving its past. "Places like the Stanley Theater," Durso argues, "are jewels that are very important to economic development, tourism, and quality of life." The antique postcard gives a glimpse of the old Colonial Theater. While much is gone, some architectural gems remain.

Designed by world-renowned architect Richard Upjohn, the old city hall was built in an Italian Renaissance style in 1853, on the southwest corner of Genesee and Pearl Streets. The old city hall features arched windows and a bell tower housing a four-faced clock. Throughout the 20th century, the building was hailed as a landmark, but its popularity and pedigree could not save it from eventual demolition in 1968. The entrance to the Radisson Hotel–Utica Centre and its parking garage now occupies the site.

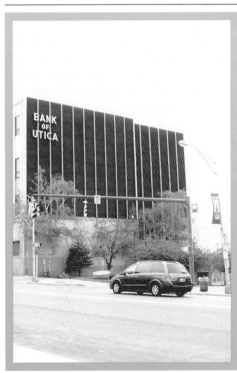

PUBLIC BUILDINGS IN THE "HANDSHAKE CITY"

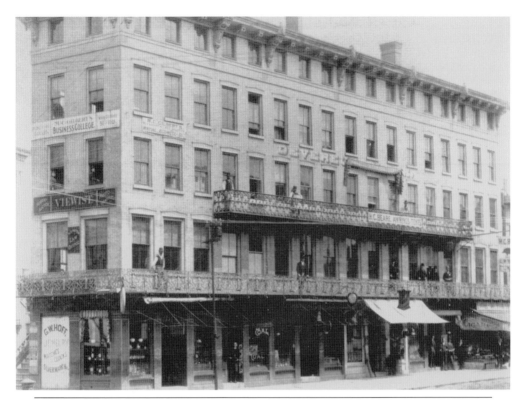

The Victorian features of the Devereux Building graced Franklin Square until 1990. Erected on the southern bank of the Erie Canal in the heart of Utica, it was a popular business headquarters and longtime home of the White Tower restaurant. Following the fourth fire in the building's history in 1990, the flat iron structure was removed and replaced with a small park featuring a welcoming sign to the city—the sort of park Uticans had envisioned for that neighborhood more than a century before (see page 95). (Historic photograph courtesy OCHS.)

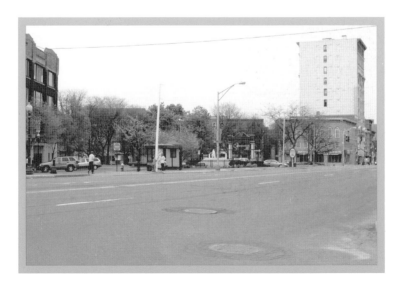

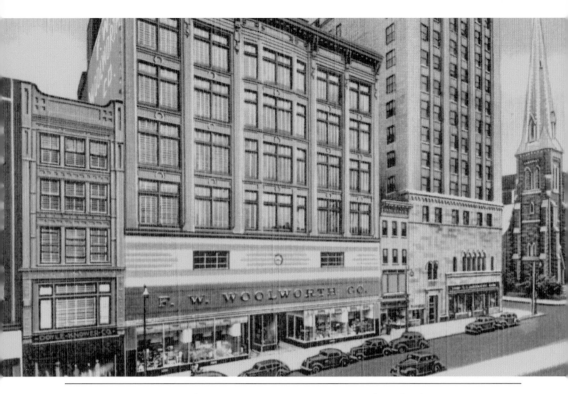

The F. W. Woolworth five-and-dime closed its doors in 1990 after 75 years in Utica. A failed start by the retailer in 1879 at the Arcade Building (Bleecker Street side) was followed by a successful venture in Lancaster, Pennsylvania. Giving it another try in downtown Utica in 1888, Woolworth's became a mainstay on Genesee Street (east side) between Elizabeth and Bleecker Streets (above), in a building with a long retail tradition. It was the site of Frazer's Department Store. The building is presently vacant.

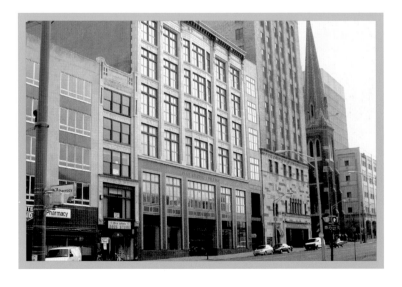

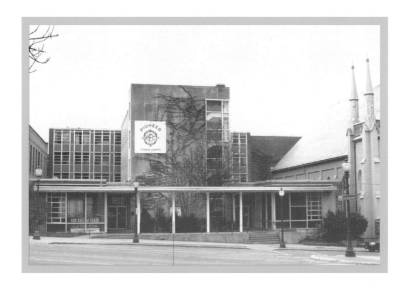

The YMCA of Utica was originally located on the southwest corner of Bleecker and Charlotte Streets in 1888, and was destroyed by fire in 1907. It then moved into temporary quarters (below) at the Balliol School (formerly a private female academy) on Washington Street just south of Westminster Church. In 1951, a major addition with a modern gymnasium and swimming pool was constructed. The old front portion of the structure was razed in 1956 with a dedication of the new building in 1958. The building briefly served as a fitness center but is now vacant.

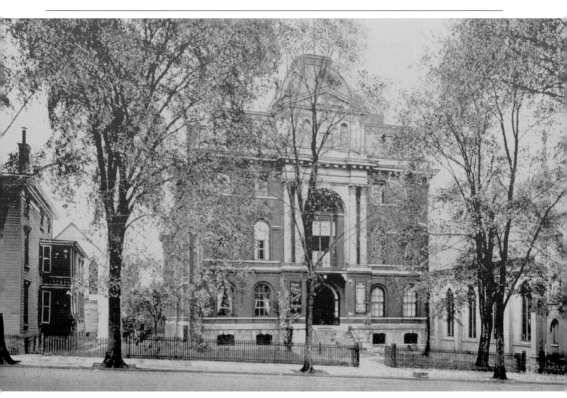

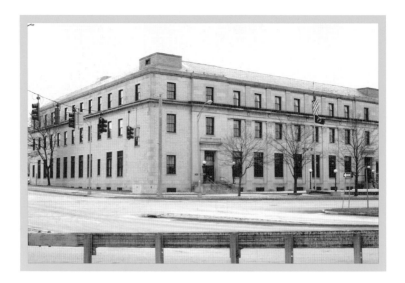

The first federal building, seen below, was erected on this site (south side of Broad Street between Genesee and John Streets) in 1882 with the help of U.S. senator Roscoe Conkling. It was torn down in 1928 to make room for a larger facility to serve as an Erie Canal customhouse, a post office, and a federal office complex. In the mid-1980s, a $2 million renovation took place, post office services ceased, and it is now known as the Alexander Pirnie Federal Building and Courthouse, also home of the 24th Congressional District offices (above).

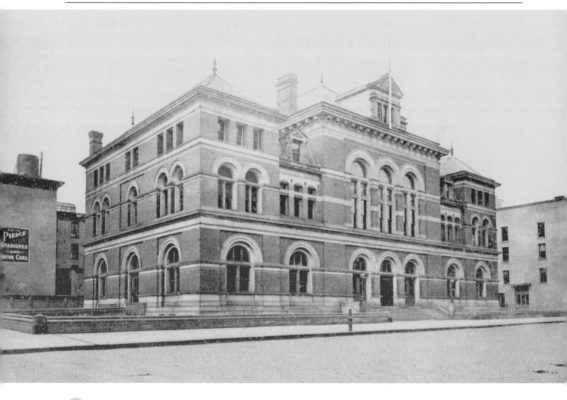

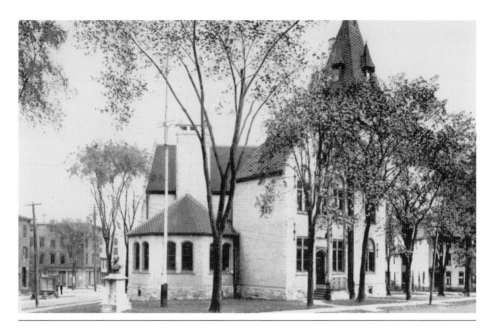

This unique structure was located on a triangular plot of land bordered by John and Elizabeth Streets and Park Avenue. Erected by the influence and finances of Helen Munson Williams in 1896, it was dedicated to her father, husband, and brother. It consisted of a lecture hall, library, and museum with historical displays by the Oneida Historical Society. It was made of yellow brick with a red-tiled roof. It was razed in 1959 after the Oneida Historical Society moved to the Fountain Elms Building at Munson-Williams-Proctor Institute on Genesee Street until finding a new home at the old First Church of Christ Scientist building (see page 77). (Historic photograph courtesy OCHS.)

In 1865, local merchant Victor Stewart erected a four-story building to house his growing dry goods store on the northeast corner of Genesee and Elizabeth Streets. Accounts differ as to whether the original structure was in fact demolished or expanded. In either case, the present 14-story Sullivanesque office building was the result. The Kressge five-and-ten occupied the ground floor from 1912 to 1925 and again from 1933 to 1962. After remaining vacant for a number of years, the building was rescued from the wrecking ball and renovated into the Adirondack Bank Building.

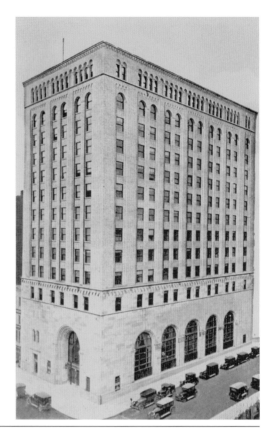

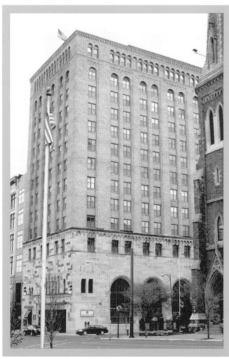

Public Buildings in the "Handshake City"

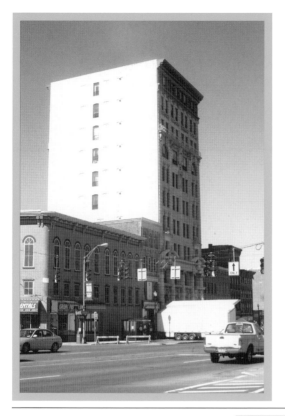

The City National Bank was a landmark for many years because it was Utica's tallest building, blending distinctive Renaissance, Beaux-Arts, and Richardson Romanesque features, most notably its ornamental cornice. The building was erected in 1904 and opened as the Utica City Bank, although settling on the Utica City National Bank moniker. Following a number of bank mergers, the bank later became the Marine Midland Trust Company, and business relocated to the northwest corner of Seneca and Columbia Streets, leaving the building behind to be converted to senior citizen housing in the early 1980s.

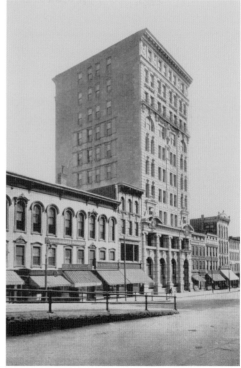

The original building on the
Commercial Traveler's Insurance
site (below), on the west side
of Genesee Street between
Whitesboro and Liberty Streets,
was erected in 1904 with one
entrance and three window bays
in the Sullivanesque style. A 1937
addition, expanding the building
but toning down its classical
architectural elements, enhanced
the structure to what it is today.
The company was founded in
1883 by Edward Trevvett, who
sensed that he and his fellow
traveling salesmen (or in the
parlance of the day, "commercial
travelers") deserved insurance
against the obvious traveling risks
of their occupation at the close of
the 19th century.

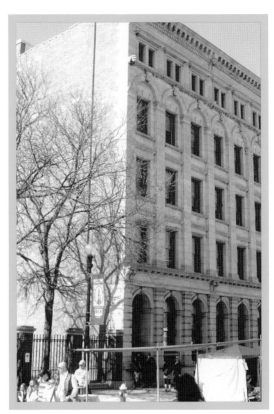

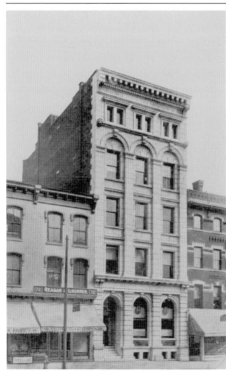

PUBLIC BUILDINGS IN THE "HANDSHAKE CITY"

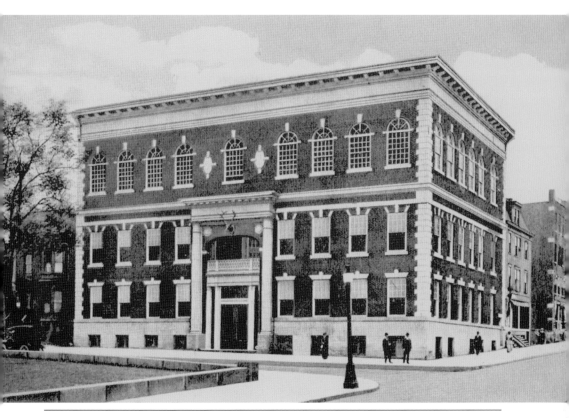

The Elks Club was erected on the southeast corner of Mary and Charlotte Streets in 1916 (Mary Street now ends at John Street). In 1942, Oneida County bought the property, where it housed the county board of elections until the early 1970s. The clubhouse was popular for its dining facilities, hardwood paneling, and spacious meeting rooms. The entrance to the Oneida County office building occupies this site today.

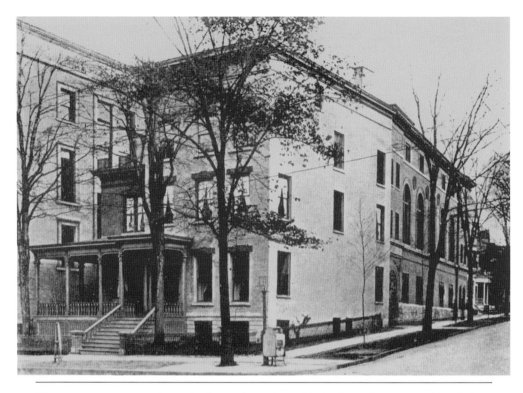

This once private residence built in the 1830s was converted into a headquarters for the New Century Club, whose aim was to promote "the moral and mental improvement of women." An auditorium was added to its east side in 1887, and its stage played host to discussions led by political activists and social leaders like Susan B. Anthony (women's suffrage), Jane Addams (settlement house movement), and Jeannette Rankin (first elected U.S. congresswoman). Former home of the Utica Community Action, it was in the process of being converted into downtown office space as this book went to print.

PUBLIC BUILDINGS IN THE "HANDSHAKE CITY"

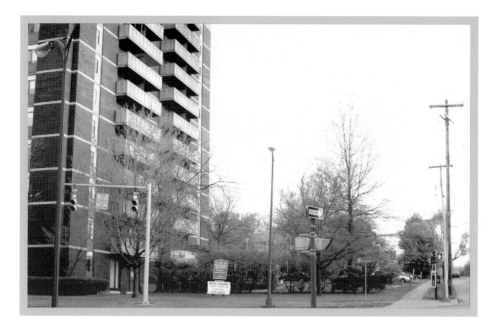

This military facility was constructed in 1893 and demolished in 1956. During its 63-year tenure, the armory served as home to many National Guard units during the Spanish-American War, World Wars I and II, and the Korean War. Being the largest building in the county for many years, it was used for many convention purposes and athletic events. A cannon of Revolutionary War fame nicknamed "Old Saratoga," said to have been captured at the Battle of Saratoga, stood guard at the armory. The building east of the armory was the Park Baptist Church (see page 79). The Park Avenue Apartments stand there today.

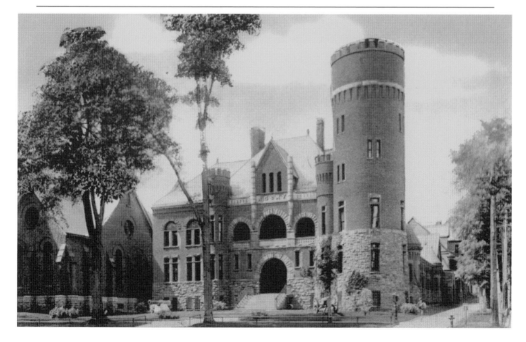

The Saturday Globe Building, erected in 1885, was located on the north side of Whitesboro Street, two doors west of Genesee Street. Founded in 1881 by William T. and Thomas F. Baker, the *Globe* had a large domestic and Canadian circulation and was read by the British royal family. It was the first illustrated American newspaper and the first to feature color prints. The presses stopped for the *Globe* in 1924, and its building became home to Horrocks-Ibbotson Company, the world's largest manufacturer of fishing equipment during the 1950s. The building was demolished following a failed attempt to create a news media hall of fame here in the 1990s. (Historic photograph courtesy OCHS.)

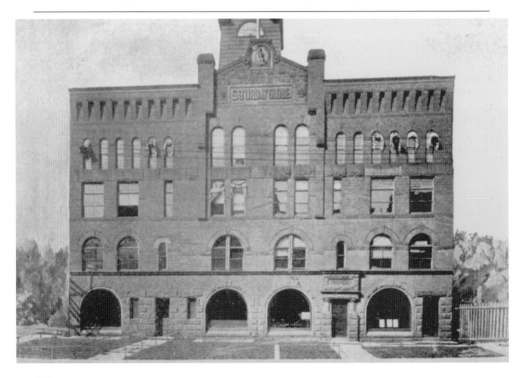

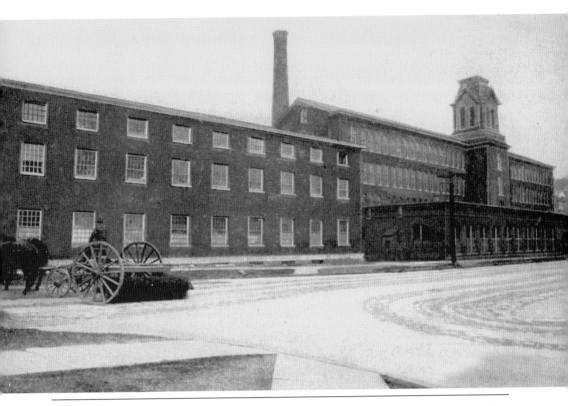

Utica entrepreneurs Alfred Munson and Theodore Faxton initiated numerous local companies, including an 1847 investment that became the Globe Woolen Mills. With the advent of steam-powered looms and the expansion of the local industry, Utica became the major source of textile production in the Northeast. This structure is the second at this site, the first having been destroyed by fire in 1871 and rebuilt in 1873. Once the home to the State University of New York Institute of Technology, it is now the home of the Utica-Rome Educational Center and other businesses.

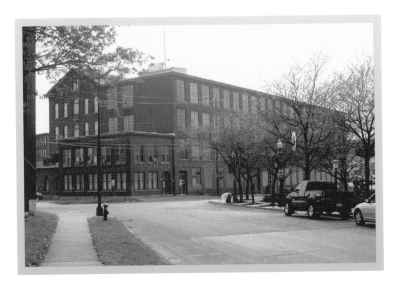

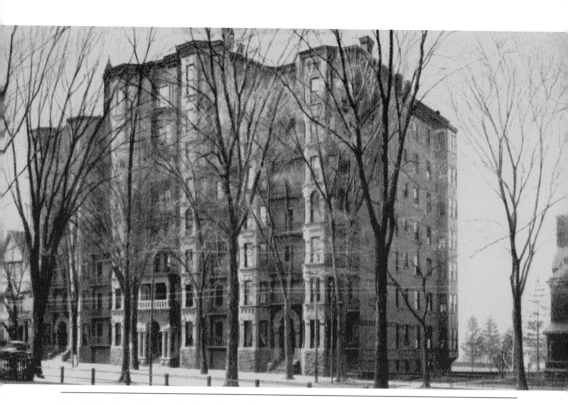

Frederick Law Olmsted, famed landscape architect, told Uticans that he thought buildings of this sort were "out of harmony with their surroundings." The Kanatenah Apartments, pictured above, was constructed in the commercial style on the west side of Genesee Street between Oswego Street and Watson Place around 1895 by Nutt and Kacher. It was demolished after a fire gutted the then run-down complex. The Colonial Laundromat is located there today.

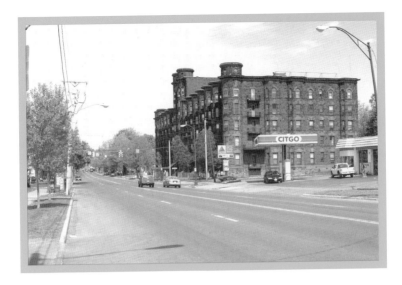

This site was initially the home of the Genesee Flats Apartments, erected in 1892 on the east side of Genesee Street and the northeast corner of Clinton Place. It was destroyed by fire in 1896. In its place a new five-story apartment building, as pictured below, was constructed by Nutt and Kacher with 125 units and named the Obilston Apartments. In 1930, some of the larger apartments were divided to create 165 apartments.

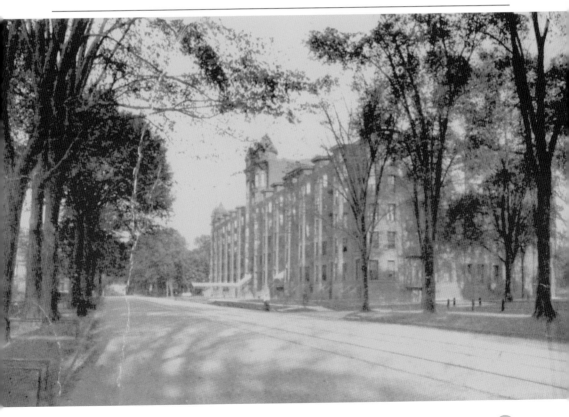

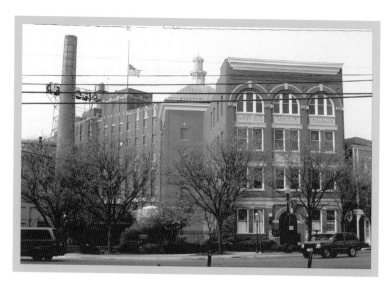

F. X. Matt II reinvigorated this family-owned brewery in the late 1980s with its now nationally celebrated Saranac line of beers. Originally dubbed the West End Brewery, Matt's Brewery was one of nearly a dozen breweries operating in the city of Utica when founded in 1888 by German immigrant and brewmaster F. X. Matt I. Family-owned, the brewery has been a catalyst for recent economic growth in the Varick Street brewery district, drawing thousands of visitors to its tour center, Saranac Thursday social events, and Saranac Concert Series. Found on the northwest corner of Varick and Court Streets, the brewery itself is an example of early commercial architecture with Victorian features. (Historic photograph courtesy OCHS.)

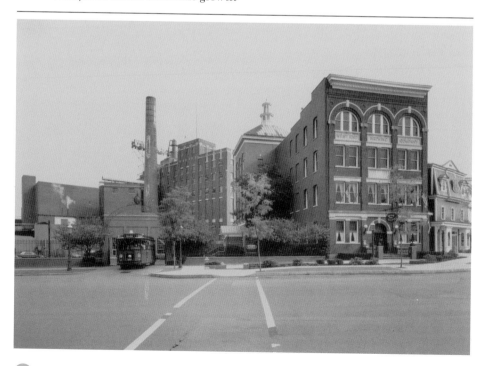

PARKS AND MONUMENTS FOR THE "BELLE OF THE MOHAWK VALLE"

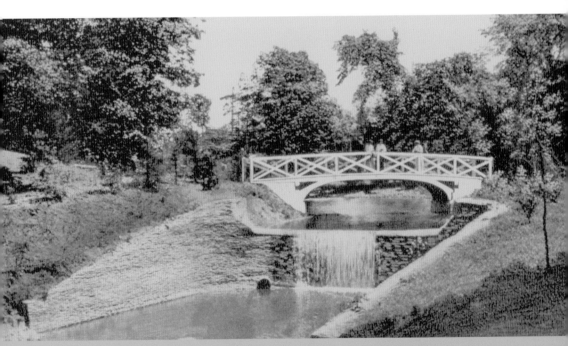

Statues and monuments are certainly indicative of what the city's ancestors came to respect and revere. Along with Utica's green spaces, like this antique rendering of Proctor Park above, they provide a respite from the confined nature of a city. Larry Whitney, vice president/regional check manager for the Federal Reserve Bank of New York agrees: "Look out there. The parks are just a part of it. Green everywhere . . . what is there not to like about Mohawk Valley's beauty?"

53

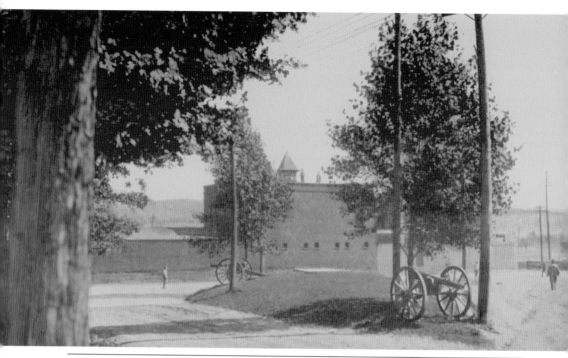

The seed that would grow into the city of Utica was old Fort Schuyler, a British military installation along the Mohawk River. To mark the 100th anniversary of Fort Schuyler's retirement, the Oneida Historical Society created this park where Main Street met what was then the northern end of Park Avenue.

Although the actual site of the fort was located approximately two-tenths of a mile northwest of this park, it was the nominal birthplace of Utica for years until its removal in 1960 for the construction of the new Route 5 south through Utica, just right of the photograph below.

Alexander B. Johnson essentially granted this land at the West and Square Streets intersection to the city in 1849, with a dollar changing hands. Johnson also has the distinction of having lived on the current site of the Partners Trust Bank corporate headquarters (see page 20). Johnson owned a significant portion of land in the Cornhill neighborhood, and the park he dedicated as a memorial to his parents remains to this day, although minus its fountain, a focal point of the park dating back to the 1870s.

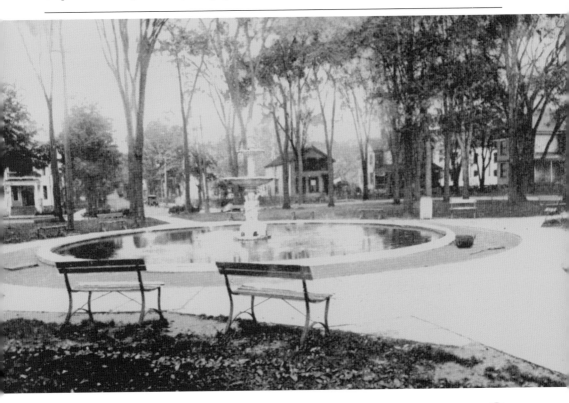

The Neptune Fountain, captured in the early-20th-century photograph, was at the heart of Chancellor Park, one of the first parks established in the city of Utica. The 8.5-foot-high fountain was installed in 1875, with a basin 50 feet in diameter and water spraying 30 feet in the air from the nostrils of two dolphins. The park was named after James Kent—the same namesake of a bordering street—who served as New York State Court of Chancery chancellor. The park remains an active site for cultural events, including events of the Utica Monday Nite series.

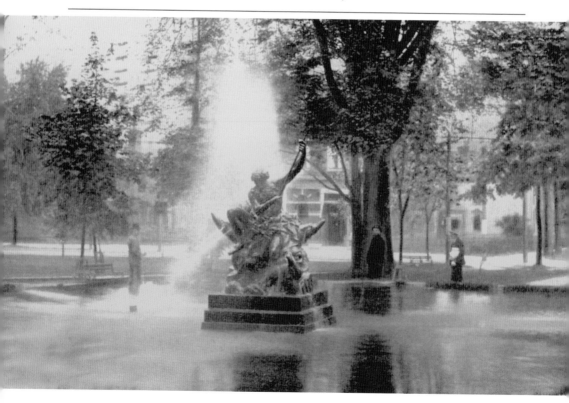

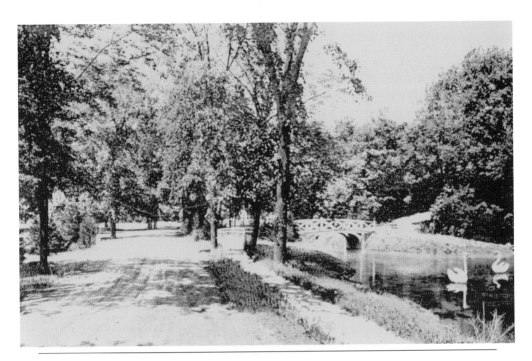

Running along the Oneida and Herkimer Counties boundary and fronted by Culver Avenue is the still popular Frederick T. Proctor Park, opened to picnickers and sightseers in 1909 and captured in this postcard in the second decade of the 20th century. Proctor, with a little help by famous park planner Frederick Law Olmsted, hoped that it would be an exemplar for other municipal parks. With a grand entrance on the northeast corner of Rutger Street and Culver Avenue, the park is a popular recreation area and place for walkers, joggers, and sports activities, with constant renovations since 1994. It runs alongside Thomas R. Proctor Park, home of major sporting events like the Boilermaker 8K Walk and E. J. Herman Cross Country Invitational.

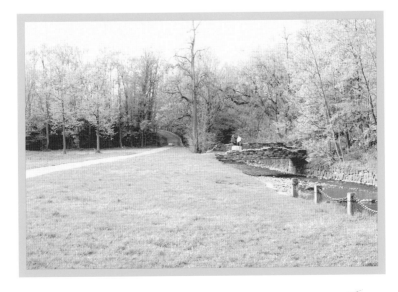

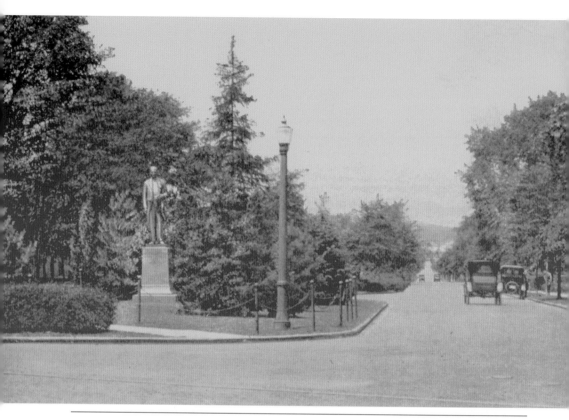

A statue of U.S. vice president James S. Sherman has greeted motorists at the east entrance to Burrstone Road at Genesee Street since its dedication by Utica mayor Fred J. Douglas in 1923. Sherman is the most successful political office seeker in the history of this city. After graduating from nearby Hamilton College, Sherman served as mayor of Utica, as a United States congressman, and as vice president under Pres. William H. Taft from 1909 to 1912.

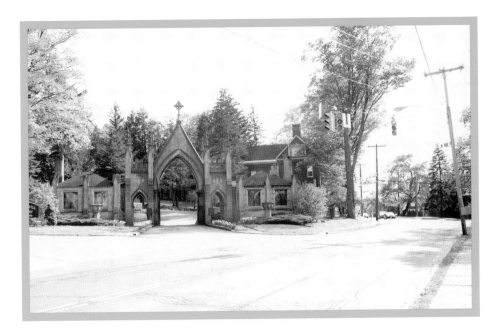

While traveling south on Oneida Street heading toward Washington Mills, passersby cannot help but notice the Gothic entrance to Forest Hill Cemetery. The cemetery was established in 1848 (its conservatory was added in 1872) and is the final resting place to many notable Mohawk Valley settlers and natives, including U.S. senator Roscoe Conkling and U.S. vice president James S. Sherman. It is also the site of significant memorials such as a massive memorial to Justus Henry Rathbone, founder of the national fraternal order the Knights of Pythias in 1864.

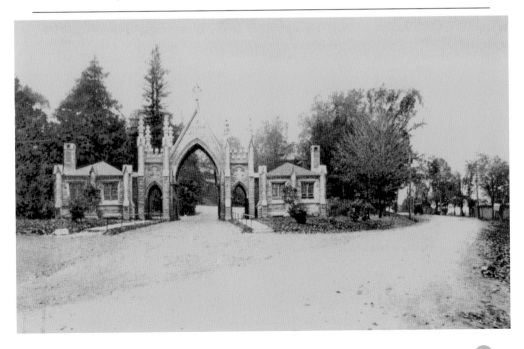

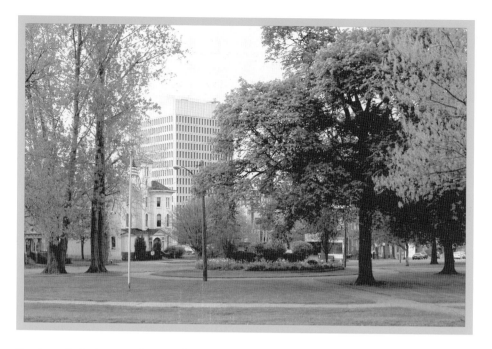

Steuben Park lies at the confluence of Charlotte, John, and Rutger Streets, a memorial to Frederich Wilhelm Baron Von Steuben. The park was established in 1827 to honor this trusted advisor to Gen. George Washington and trainer of the Colonial troops during the American Revolution. In 1832, Park Avenue was truncated at Rutger Street to avoid its running through the area, reducing what may have been "Steuben Square" to a mini-park. People may still enjoy Steuben Park today, although the elaborate fountain is now absent.

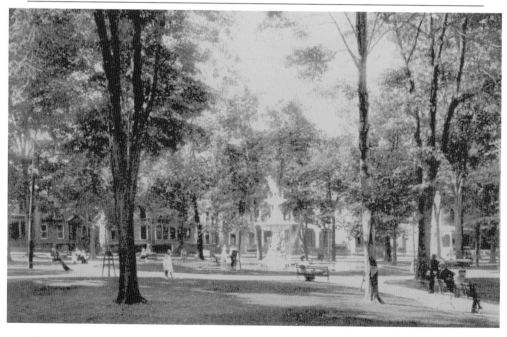

PARKS AND MONUMENTS FOR THE "BELLE OF THE MOHAWK VALLE"

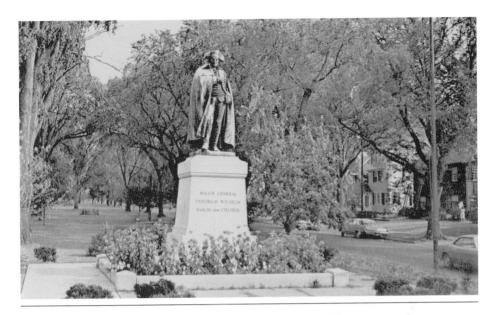

Major general of the American Continental army, Frederick Wilhelm Baron Von Steuben holds a majestic military stance while looking westward from the center mall of the memorial parkway at Genesee Street. The statue was a gift in 1914 of the Utica German-American Alliance, to honor Steuben, a military drill instructor to Washington's troops while encamped at Valley Forge. There is some dispute among historians regarding Steuben's claim to his lavish title and alleged prominence within the Prussian army of Frederick the Great. There is no question, however, that Steuben nurtured Washington's army to higher standards, and the man historian Joseph Ellis has termed "a lovable fraud" still stands in memoriam in battlefields around the country and at Utica's parkway.

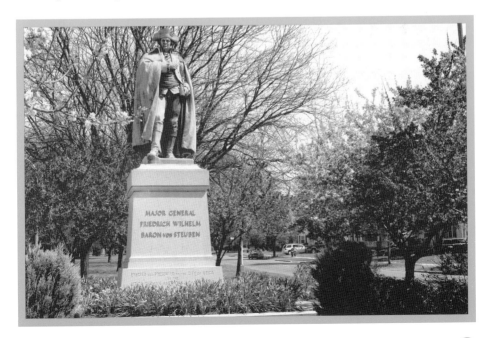

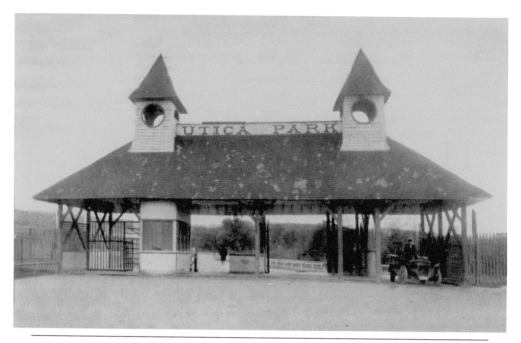

Utica Park was located along the south side of Bleecker Street just east of the Masonic home grounds. Only a short trolley ride away from the city, this multipurpose park featured a number of diversions for Uticans, such as a small amusement park, a horse track, and a dance pavilion featuring the Rath Band, as well as a baseball diamond and pavilion. The park remained active from 1891 until 1934. Even though the Great Depression could not destroy the popularity of this center of amusement, the automobile did. A section of Utica Park eventually became the site of Chicago Pneumatic Tool Company parking lot from 1949 to 1997.

CHAPTER 5

HOMES AND HOTELS IN THE "HUB OF THE EMPIRE STATE"

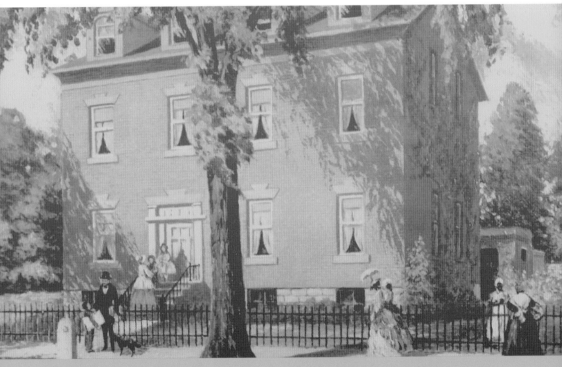

Joseph R. Carucci, president of Carucci Real Estate and the Hotel Utica, suggests that "preservation and restoration are critical priorities if we are going to have Utica's past be a part of her future. The restoration and maintenance of our architectural heritage is a necessary step toward revitalizing the whole region." Such thinking inspired Carucci, along with real estate developer Charles Gaetano Jr., to restore the Hotel Utica (see page 13), all in hopes of adding to the experience of a city founded by civic-minded individuals like Utica mayor John Devereux, whose home is pictured above. (Historic photograph courtesy Partners Trust Bank.)

The home of prominent native son Horatio Seymour, seen below, once stood on the northwest corner of Whitesboro Street and Hotel Alley at the foot of Hotel Street. Seymour served as mayor of Utica and New York State governor and was defeated by Ulysses S. Grant for the U.S. presidency in the election of 1868. The building, a mixture of Federal and Dutch architecture, eventually served as a small factory, as well as office and warehouse space for small businesses. The building was razed in the early 1980s and with it the last remnants of either Seymour homestead (a Seymour farmhouse in nearby Deerfield—partially the site of the State University of New York Institute of Technology campus—was destroyed by fire in 1962). (Historic photograph courtesy OCHS.)

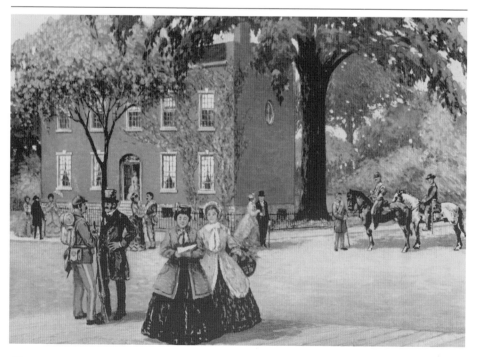

HOMES AND HOTELS IN THE "HUB OF THE EMPIRE STATE"

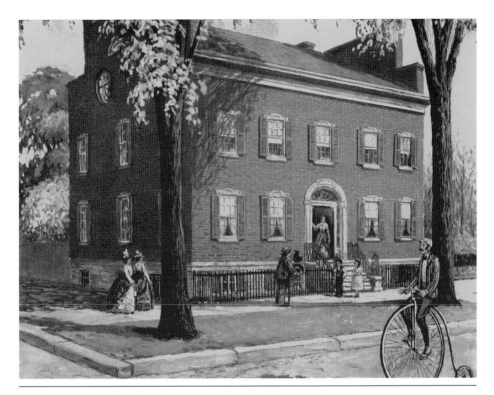

This ostentatious mansion was located on the northeast corner of Broad and First Streets, a preferred residential neighborhood in the early 1800s. The house was distinctive for its elaborate central staircase and English paintings. It was originally planned by designer Philip Hooker in 1825 as the home for merchant Samuel Stocking and was later home to Hiram Denio (noted judge and Savings Bank of Utica president) and then his daughter Elizabeth Tourtellot. With modifications, it became the sales garage of Brockway Trucks in 1919 and was razed about 1924 to make way for the new Coca-Cola Bottling Company, which was replaced in 1965 by Top Tile Building Supplies Corporation. This site now sits vacant. (Historic photograph courtesy OCHS.)

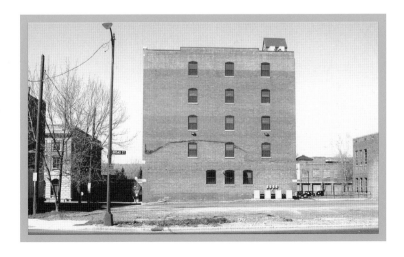

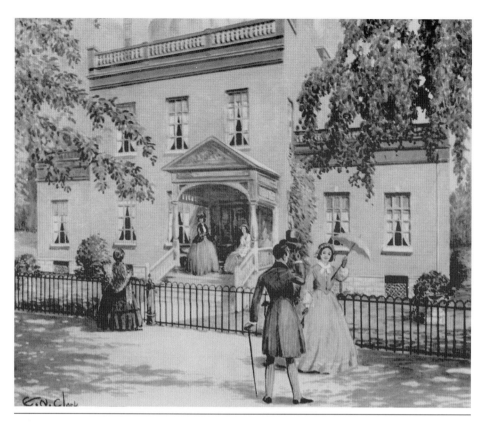

The Bagg Mansion, located on the northwest corner of Broad and Second Streets, was built in 1824 and possessed one of the finest gardens of its day. In A *Sketch of Old Utica*, author Blandina Dudley Miller notes that the house featured "beautiful rooms displaying high mantle pieces with elaborate carvings." The home of one of Utica's more famous citizens was demolished in the early 1900s. A beautifully restored and remolded building housing the Cobblestone Construction Company now occupies this corner. (Historic photograph courtesy OCHS.)

HOMES AND HOTELS IN THE "HUB OF THE EMPIRE STATE"

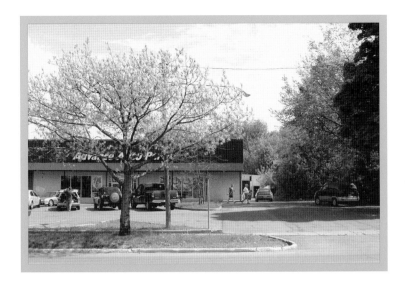

This home was the location of a great celebration upon the selection of James S. Sherman as vice presidential candidate on the Republican ticket with William H. Taft. It was located on the east side of Genesee Street between Clinton Place and Jewett Place, approximately where the Western Auto's Parts of America store is today. Many notable leaders, such as Pres. William H. Taft, were hosted at this home before Sherman's untimely death just before the election of 1912.

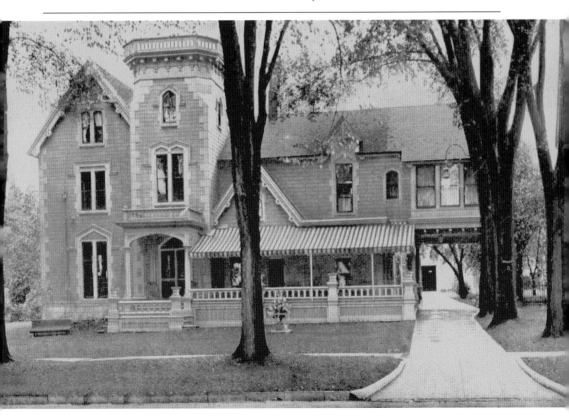

During Utica's urban renewal phase, Utica vanquished two entire city blocks to make way for the Sheraton Inn, now the home of the Radisson Hotel–Utica Centre. This location was once the home of the Gardner Building and, immediately to its south, the Evans Block. Both were situated on the west side of Genesee Street between Pearl and Columbia Streets. In the early part of the 20th century, the Evans Block was the home of the Utica Conservatory of Music, and the Gardner Building rented to popular retailers.

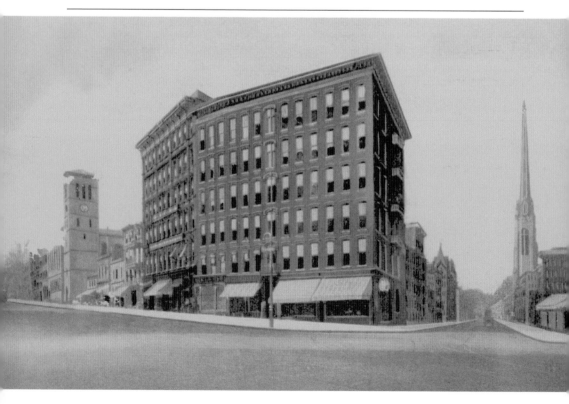

HOMES AND HOTELS IN THE "HUB OF THE EMPIRE STATE"

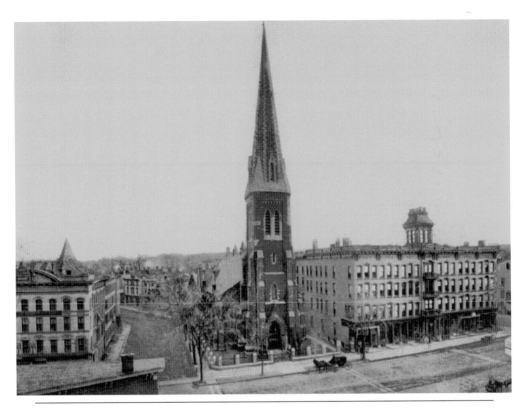

The Butterfield House (above, right) was erected on Genesee Street in 1869 by John Butterfield, former Utica mayor and founder of the Overland Mail Service, forerunner of the American Express Company. The hotel was considered one of the finest in the Northeast and was the Democratic Party headquarters for Gov. Horatio "the Sage of Deerfield" Seymour. The building was demolished in 1910 to make room for the Roberts Dry Goods Store, which years later became the J. B. Wells department store. Today the site is the home of the Macartovin Apartments.

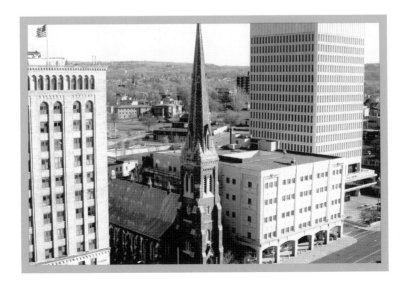

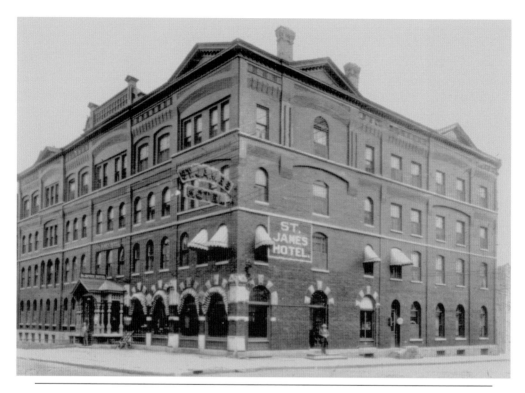

Located immediately west of Bagg's Square, the St. James Hotel was built in the heart of downtown Utica in 1886 on the north side of Whitesboro Street. Business boomed for the St. James when the Butterfield House closed, and the four-story, 90-room hotel became known for its elegant marble floor and hard cherry woodwork. The St. James diminished in prominence when the city continued to develop southward away from Bagg's Square. The Bagg's Square roadway and bridge project of the 1970s isolated the hotel enough to force it to close its doors in 1992. It was razed a few years later following a fire. (Historic photograph courtesy OCHS.)

HOMES AND HOTELS IN THE "HUB OF THE EMPIRE STATE"

This location, on the north side of Lafayette Street between Seneca and Washington Streets, was home to the Mechanics Association, which was renovated in 1890 to become the Utica Opera House, home for off-Broadway shows. It was razed in 1899 and replaced by the Majestic Theater. The theater eventually made room for the Majestic Hotel in 1923. It was soon purchased and renamed the Pershing Hotel, which operated until 1963. The former site of the Pershing Hotel now serves as a parking lot for the rejuvenated Hotel Utica. (Historic photograph courtesy OCHS.)

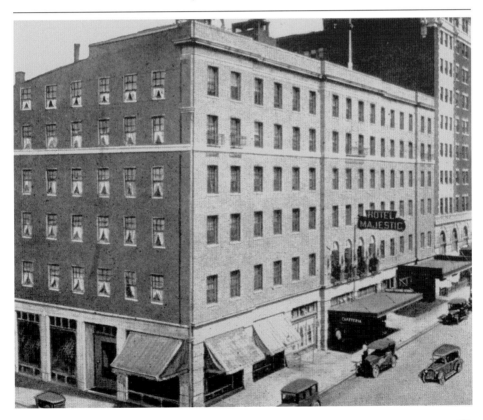

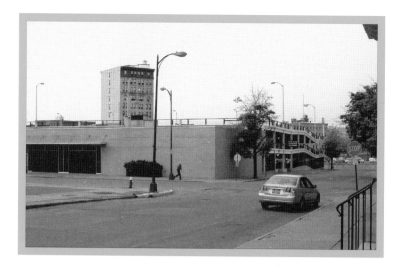

During the late 1800s, the four-story Hotel American occupied this site on the north side of Bleecker Street at the former Market Street. In 1901, a local farmer bought it and renamed it the Hotel Martin and built a seven-story hotel to its west around 1911. In 1927, he enlarged the two hotels and added an entrance on the Oriskany Street side (facing north), making it the largest Utica hotel of its time, replete with 450 guest rooms. Purchased by John Cabot in 1941, it was renamed the Hotel Hamilton, seen below, and was removed in 1966 to make room for the Boston department store annex, an addition that now houses the Utica School of Commerce.

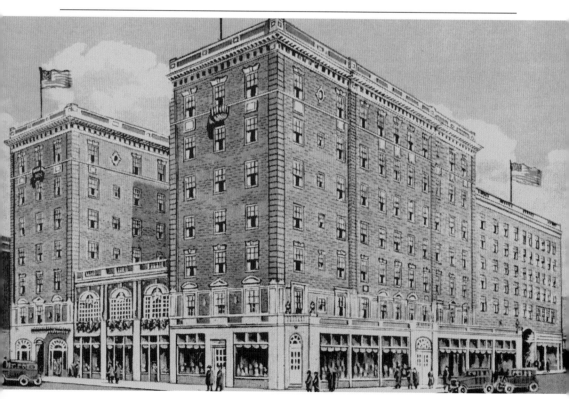

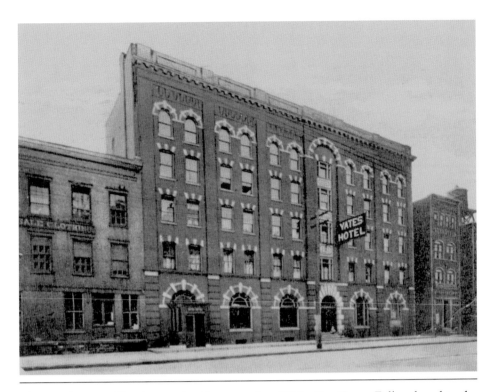

The McGregor's Hotel was the first to be located on the southwest corner of Genesee and Whitesboro Streets in 1830. It was purchased and renovated in 1852 and renamed the Dudley House. Roscoe Conkling was a resident there before his marriage and fame as a U.S. senator. In 1905, C. Yates Fuller bought the 100-room hotel, spent a considerable sum of money renovating it, and changed the name to Yates Hotel. It was demolished in the 1970s to make way for the Bagg's Square bridge project. (Historic photograph courtesy OCHS.)

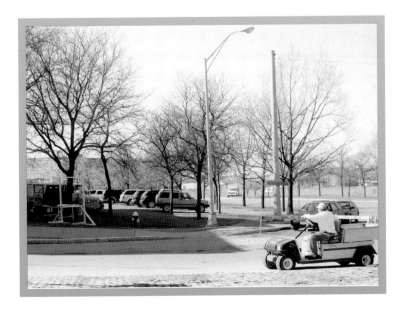

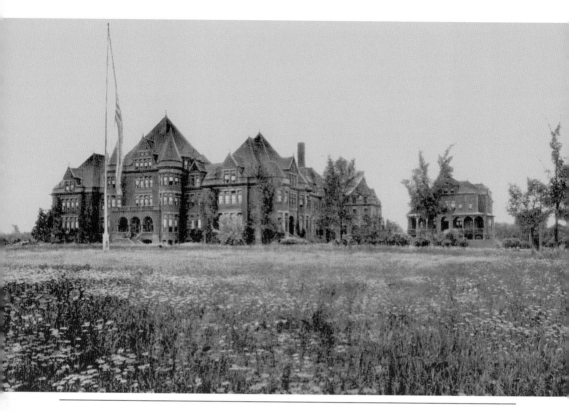

The majestic Masonic home administration building, finished in 1893, was a dominant presence for eastern-bound travelers on the south side of Bleecker Street. The Masonic home was initially established to provide sanctuary for the orphaned children of Freemasons, yet the famous fraternal order expanded the purpose of this site to include an assisted-living facility, a renowned medical research laboratory, and a breathtaking temple of the Knights Templar. The administration building was demolished in the mid-1960s and made room for the site's diverse offerings.

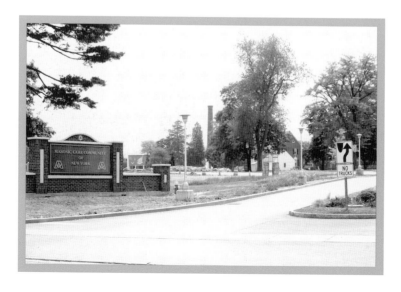

HOMES AND HOTELS IN THE "HUB OF THE EMPIRE STATE"

WORSHIP AND EDUCATION IN THE "GATEWAY TO THE ADIRONDACKS"

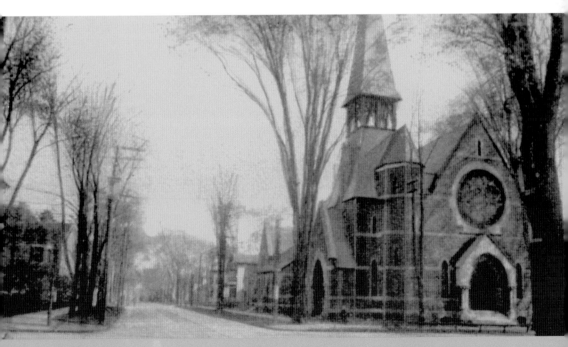

Church facilities have changed in Utica nearly as much as its educational institutions. Carmela Brown, director of performing arts and music for the Utica City School District, knows firsthand that the quest for premium public service has a long tradition in the city. "Our facilities management team is always looking to make appropriate transformations to our buildings," she says, "to suit changes in technology and our educational needs."

St. Patrick's Church, razed in 1968, was first built on the southeast corner of Columbia and Huntington Streets in 1851. A fire destroyed the building in 1890. Officials of the diocese had to reverse their decision not to rebuild due to an outcry from the parishioners. It was rebuilt in 1894–1895 and served this West Utica neighborhood. In 1966, it merged with St. Joseph Church located diagonally across the street just west of the northwest corner of Columbia and Varick Streets.

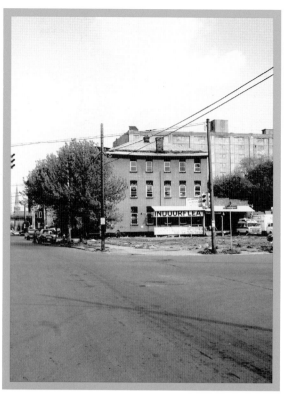

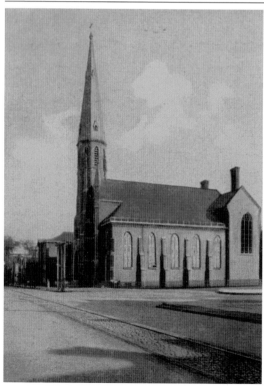

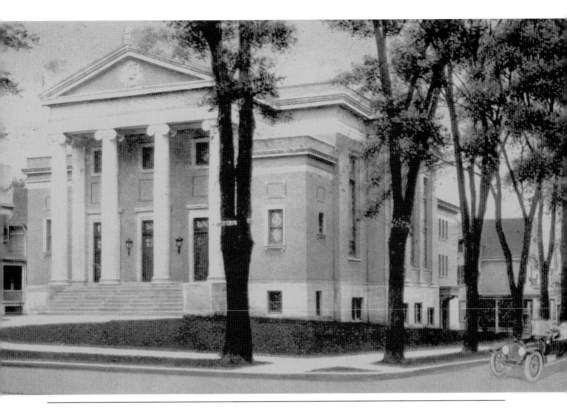

Although the Christian Science movement arrived to Utica in 1888, its church was not constructed until 1914. After moving the location of their services to larger quarters several times, Christian Scientists founded their permanent home on the southwest corner of Genesee Street and Avery Place. Due to dwindling membership in the late 1980s, this impressive structure of the neoclassical revival architecture was sold to the Oneida County Historical Society, today serving as the society's headquarters and museum. (Historic photograph courtesy OCHS.)

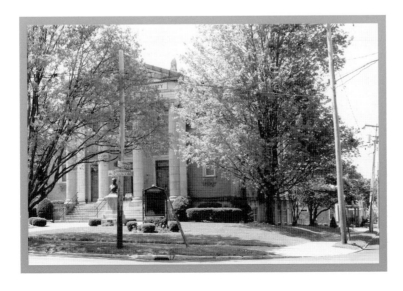

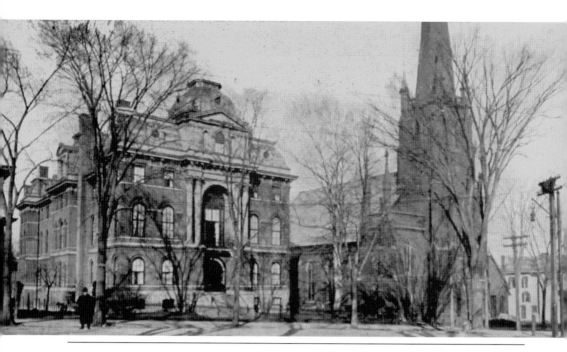

Parishioners established the Westminster Presbyterian Church by first choosing property on Washington Street in 1852. The new church was completed in 1855 and gradually earned a reputation as one of the finest church houses in New York, complete with an auditorium, kitchens, parlors, and classrooms. In 1867, 50 ladies met at this church to organize what was named the Protestant Home for Respectable, Indigent and Aged Women of Oneida County in the City of Utica.

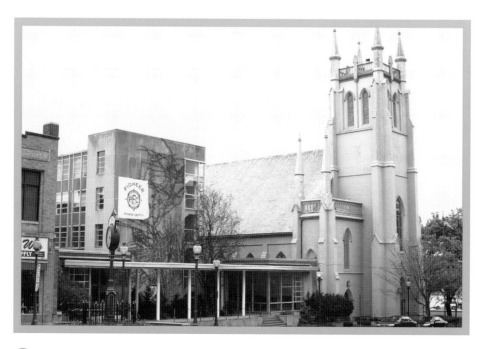

WORSHIP AND EDUCATION IN THE "GATEWAY TO THE ADIRONDACKS"

The Park Baptist Church's parishioners originally worshiped at the Bethel Church on State Street, which, with a couple of stops along the way, relocated to a beautiful new structure, seen below at Rutger and West Streets in 1888. It was here that the first vacation Bible school for children was established in 1920. In 1930, it united with the Tabernacle Baptist Church (see page 81). The building was razed in 1939 by order of the City of Utica because it was in a state of disrepair. The Park Avenue Apartments now occupy its site.

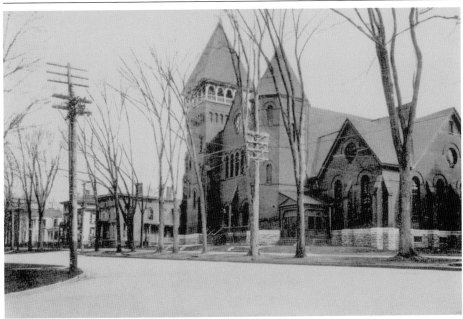

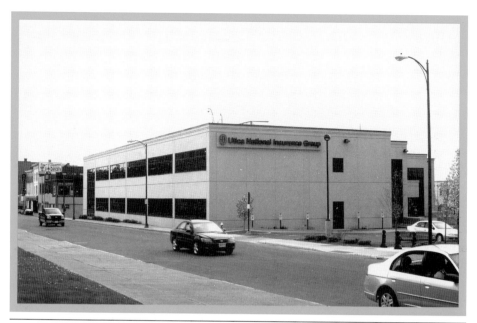

First Presbyterian Church, on the northwest corner of Columbia and Washington Streets, was erected in 1852 and was the third home of the parish known as United Society of Whitestown and Old Fort Schuyler (established in 1793). The parish relocated in 1924 to the corner of Genesee and Faxton Streets, where its still maintains an active congregation. The site of the original edifice is now occupied by the new Utica National Insurance Company property, as Washington Street now ends at Lafayette Street, not extending to Columbia Street.

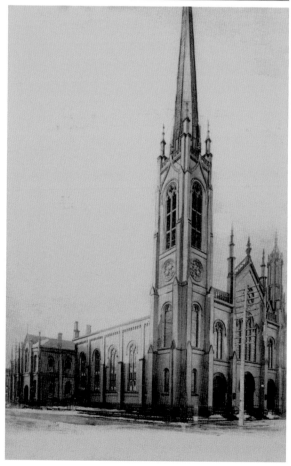

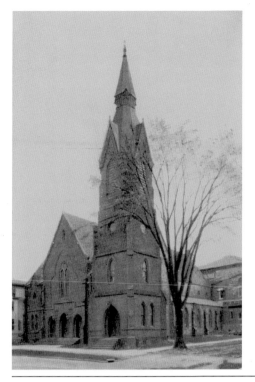

The parish that now calls the Tabernacle Baptist Church home first drew members to the Second Baptist Church, when the English-speaking members of Welch decent (of the First Baptist Church, established in 1801) desired services in English and built a new church on Broad Street. As both the membership and building aged, most of the congregation merged with members of the Tabernacle Baptist Church. A lot at the southeast corner of Hopper and King Streets was purchased in 1864, with the church building dedicated in September 1866. The present Tabernacle Baptist Church was dedicated in 1906.

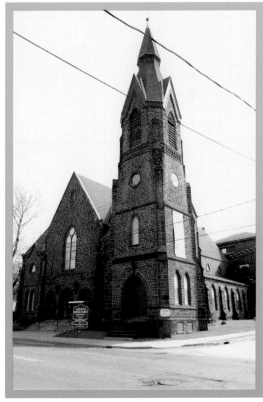

The First Universal Church was located on the west side of Seneca Street, directly south of Maher Brothers Clothing Store. This late-1880s photograph does not show one of the church's most unique features: a tree growing out one of its towers. A crevice at the top of the tower provided fertile ground for seed to evolve into an 8- to 10-foot tree. This single feature gave this church national acclaim following a local newspaper story that circulated nationwide.

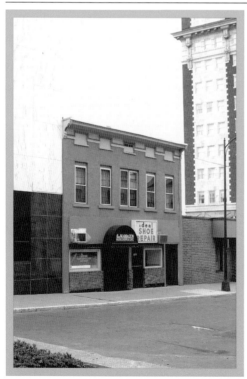

The Trinity Episcopal Church, at the southeast corner of Broad and First Streets, was partially sponsored by Trinity Church in New York City. Although its congregation was conceived in 1798, its church building was not completed until 1810, based on a design by famed Albany architect Philip Hooker. It counted among its parishioners the notable Horatio Seymour (twice governor of New York State and a presidential candidate) and U.S. senator Roscoe Conkling. It later merged with St. Luke's Memorial Church to form All Saints Episcopal Church on Faxton Street. The original Trinity church building was condemned and torn down in 1927.

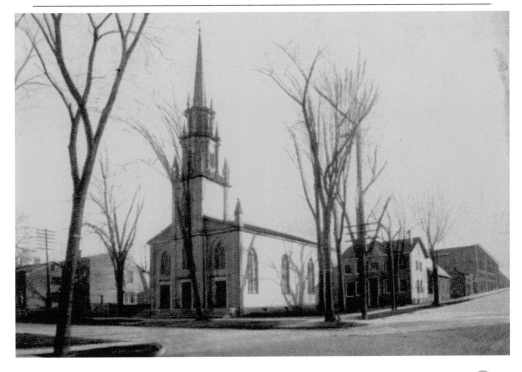

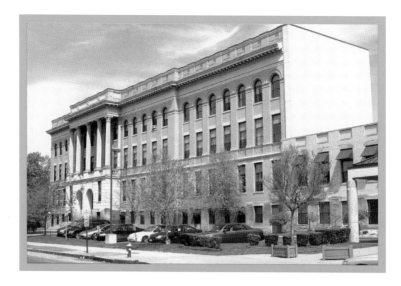

Originally built in the Renaissance Revival style, Utica Free Academy was opened in 1899 after fire partially destroyed the building a year earlier. In 1987, it became known as Utica Senior Academy with the additions of Proctor High School and Kennedy High School. In the 1990s, Utica's only high school was relocated to the Proctor facility in east Utica, and Utica Free Academy became a nursing home and adult day care center.

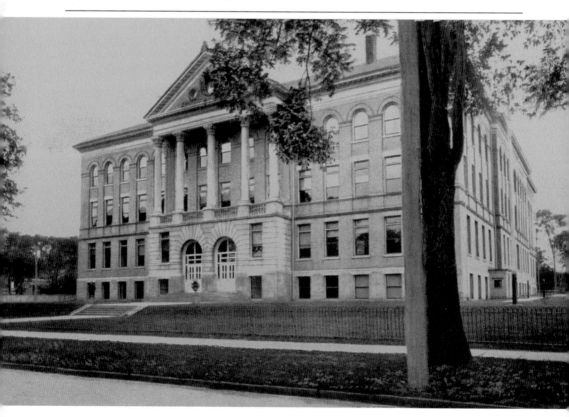

WORSHIP AND EDUCATION IN THE "GATEWAY TO THE ADIRONDACKS"

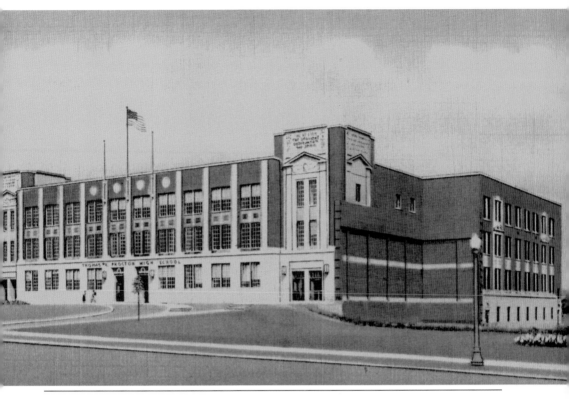

Built partially by the U.S. Works Progress Administration during the Great Depression, Proctor High School opened in September 1936. It was a city request due to overcrowding at Utica Free Academy (see page 84). It became the city's only high school in early 1990s when the merged academy relocated there from the Utica Free Academy campus. A large addition was built recently to accommodate cooperative classes and shared athletic facilities with Mohawk Valley Community College.

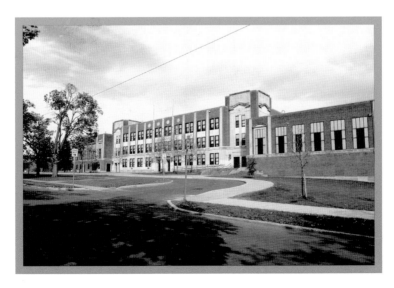

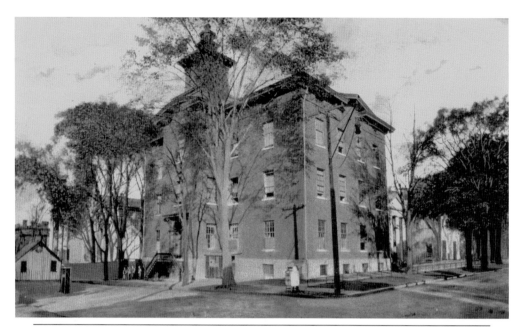

Assumption Academy was located on the northeast corner of John and Elizabeth Streets from 1854 to 1932. First operated by the Christian Brothers (1854–1914), the school was later staffed by the Xaverian Brothers (1917–1932). Xaverian principal Brother Gilbert, formerly of the St. Mary's Industrial School in Baltimore, Maryland, had the distinction of being the first to promote the baseball talents of a young Babe Ruth. Used by the Utica Work Bureau and the Works Progress Administration in the last days of the Depression, the school was razed to make room for parking. An apartment complex now occupies this site.

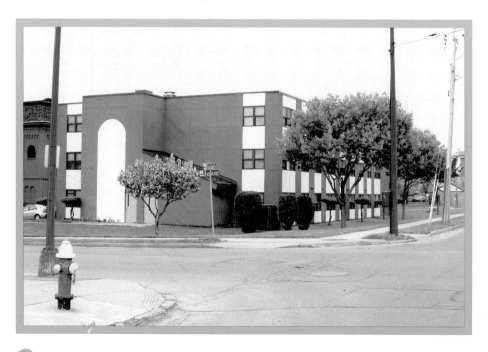

STREET SCENES OF "ELM TREE CITY"

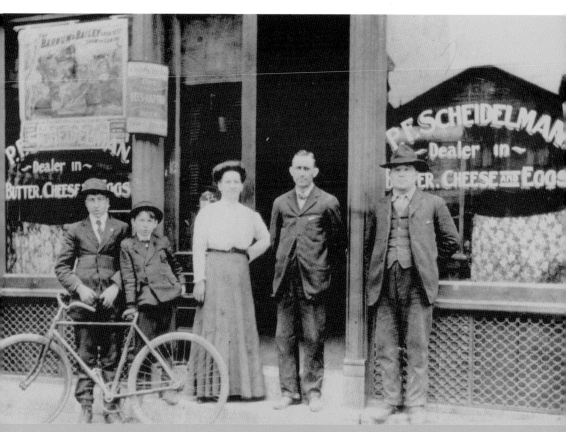

Gary and Jennifer Wereszynski, owners of the property investment firm the Fort Schuyler Group, know what it means to help revitalize a neighborhood. "When we walk through the streets of Utica," Gary says, "we can experience the city's rich history—but my wife and I know that it now falls to our generation to reinvigorate the spirit that motivated our forefathers to craft this city. It is that sort of spirit that can truly energize generations to come." Utica's Varick Street—as seen generations ago in the photograph above—is one street that has experienced a rebirth in recent years. (Historic photograph courtesy OCHS.)

The scene below captures Utica at the beginning of the 20th century, while Utica could still claim to be the textile capital of the world, powered by 19 mills and countless workers. The proprietor of the Sullivan and Slauson Drugstore (northwest corner of Genesee and Lafayette Streets) bestowed the title of "Busy Corner" to this neighborhood given its immense foot traffic and converging trolley lines at the intersection of Genesee, Bleecker, and Lafayette Streets. The five-story Devereux Building in the center of this vintage scene was demolished in 1990 (see page 37).

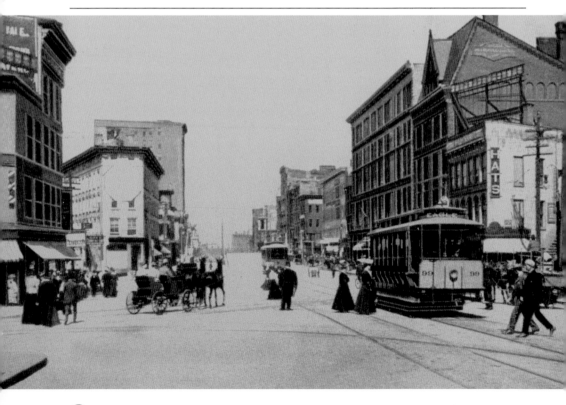

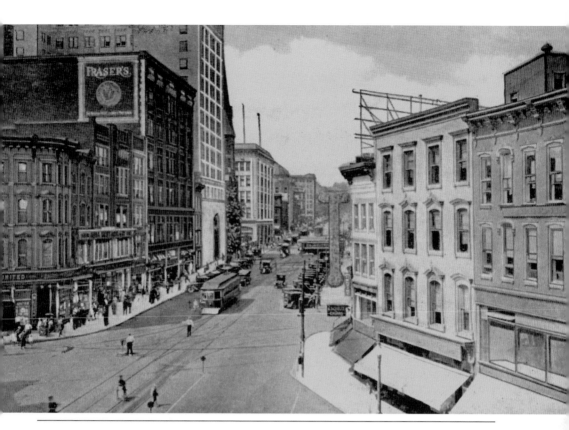

The scene above of downtown Utica, looking south along Genesee Street, documents the many trolleys that ran through the city before World War II. The five-story building in the middle of the picture is the J. B. Wells department store, just south of Grace Church. Another department store, the C. A. Wehlan Cigar and Tobacco Shoppe stood on the southeast corner of the Genesee and Lafayette Streets intersection, diagonal to the current site of Utica's Liberty Bell Park.

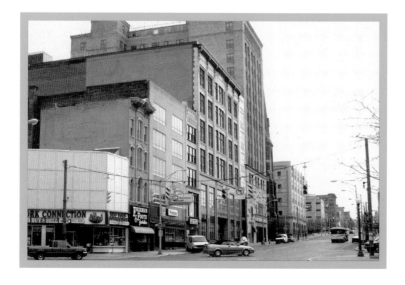

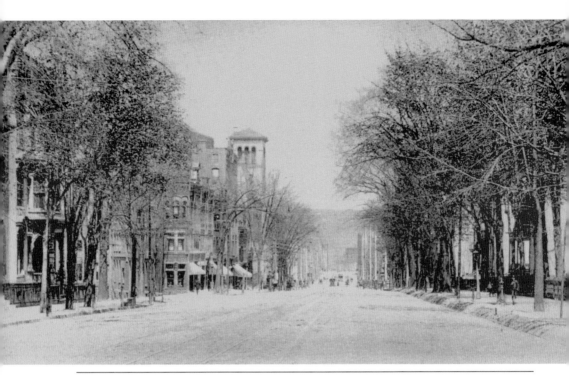

Looking northward on Genesee Street, one could appreciate the abundance of trees, encouraging "Elm Tree City" as one of Utica's popular nicknames. Two important items are noticeable in this early-20th-century photograph: the tower of old city hall is visible on the west side of the street, and trolley tracks continue to run along the street Mayor Edward Hanna would dub "Our Five Star Main Street" in the 1990s.

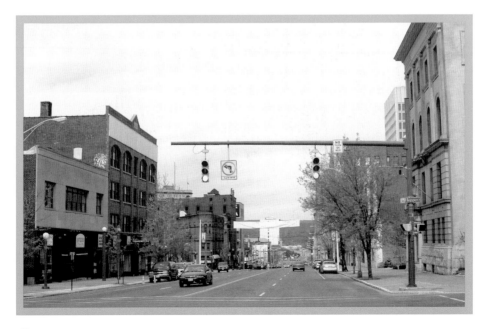

STREET SCENES OF "ELM TREE CITY"

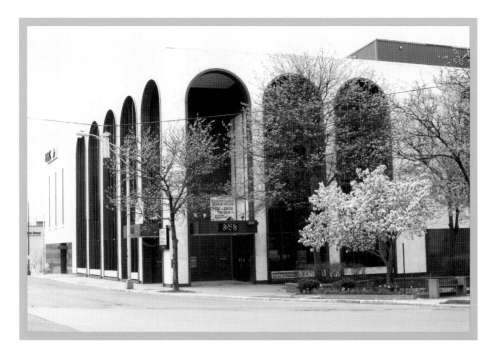

This early-1900s bank was located on the west side of Seneca Street. Citizen's Trust eventually acquired the whole corner, expanding the facility when it became the First Bank and Trust. In the 1960s, the Marine Midland Bank Company, now HBSC Bank, demolished the old bank for a new structure, seen above. The early-1900s photograph shows the Maher Brothers clothiers to the right at the corner of Seneca and Lafayette Streets (see page 94).

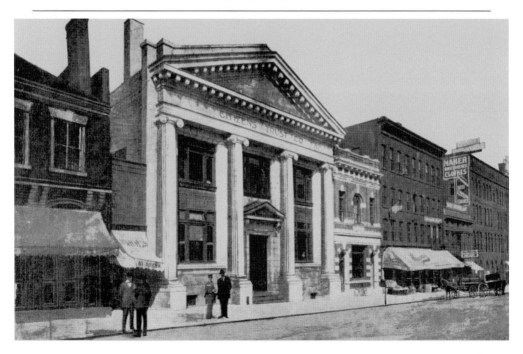

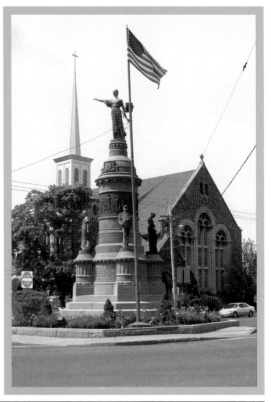

After months of debate during the late 1800s, Uticans finally agreed to erect the soldiers and sailors monument at Oneida Square in 1891 as a memorial to Civil War veterans. Sculptor Karl Gerhardt chose the archetype of a woman to represent Utica, with a hand outstretched to the consecrated Southern battlefields. Several other figures representing peace, victory, and the armed forces stand along the first level of the monument, which has since been used as a focal point for acknowledging veterans of all conflicts.

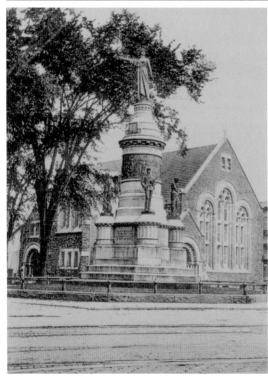

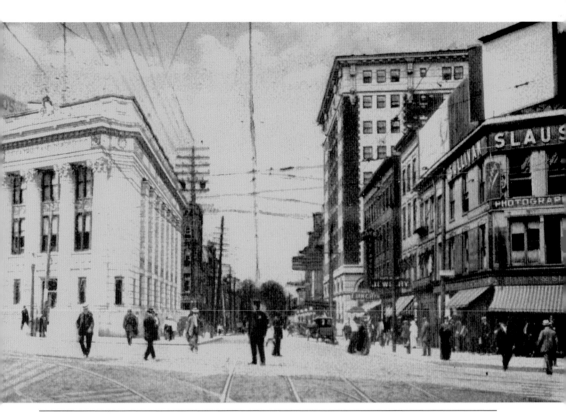

This southwest corner of Genesee and Lafayette Streets was once the home of many banks. It was the original home of the Savings Bank of Utica, dubbed the "Old Iron Bank" because its facade was fashioned to resemble plates of iron. In 1900, it became the Utica Trust and Deposit Bank as the Savings Bank of Utica moved farther south on Genesee Street. Many banks merged at this site following the Great Depression, yet today the corner is best known as the home of technology company Black River Systems.

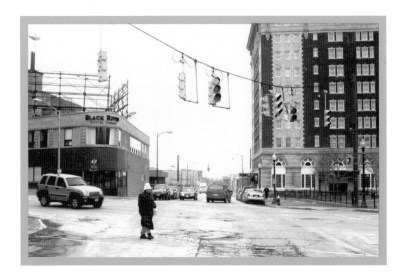

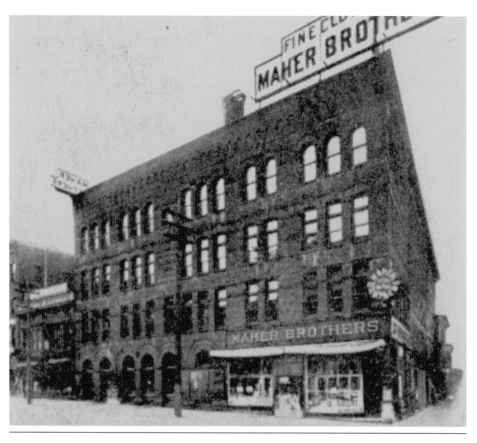

In 1874, merchant Edward Maher founded his first retail business on 38 Genesee Street, eventually moving operations to the southwest corner of Lafayette and Seneca Streets, as seen above. Maher Brothers was a major shopping destination of its day, offering premium-quality menswear. During the 1970s, the retailer moved once again and then closed shop in 1974, ending a century-long shopping tradition in downtown Utica. The southwest corner of Seneca and Lafayette is now the home of the Butterfield Post Office, named in honor of American Express founder and local entrepreneur John Butterfield.

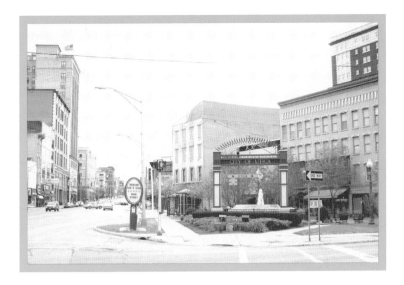

This early-1900s view of Franklin Square captures a couple of vintage Utica landmarks, including the "Hump Bridge" that carried trolley and pedestrian traffic over the Erie Canal. The white triangular building at the center of this postcard is the Devereux Building, now the site of the Franklin Square Park that greets motorists with a key to the city. Such a park was envisioned by early citizens of Utica before the 1845 erecting of the Devereux Building.

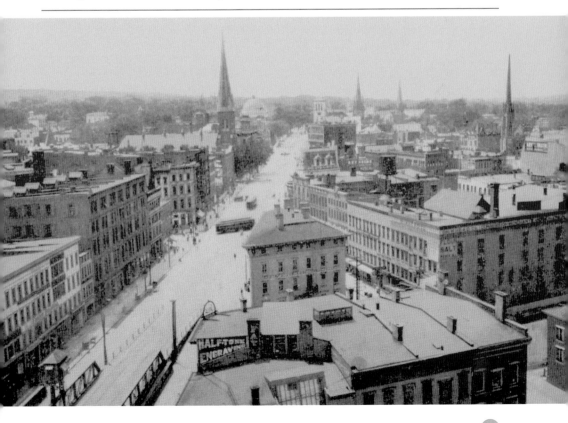

STREET SCENES OF "ELM TREE CITY"

ACROSS AMERICA, PEOPLE ARE DISCOVERING SOMETHING WONDERFUL. *THEIR HERITAGE.*

Arcadia Publishing is the leading local history publisher in the United States. With more than 3,000 titles in print and hundreds of new titles released every year, Arcadia has extensive specialized experience chronicling the history of communities and celebrating America's hidden stories, bringing to life the people, places, and events from the past. To discover the history of other communities across the nation, please visit:

www.arcadiapublishing.com

Customized search tools allow you to find regional history books about the town where you grew up, the cities where your friends and family live, the town where your parents met, or even that retirement spot you've been dreaming about.